THE ART
OF THE
DISNEY
PRINCESS

Introduction by Glen Keane

EDITIONS

NEW YORK

A Morning Spent with a Princess

My room is dark but for the light that illuminates my animation desk. The story is written, the voice recorded. I know what this moment in the movie must be. It is when our heroine reveals her deepest longing. It is an impossible dream she believes in. But that is what Disney Princesses are made of—the ability to believe that the impossible is possible. Like a flame that burns brightly in the darkness, her heart expresses itself in song. I have been listening to the song for weeks as I drive back and forth between the studio and my home. The music permeates my mind. It is in my dreams. I know every pause, inhalation, and inflection in the singer's performance. I have imagined how our Princess will move with each phrase, how her head will turn to deliver a certain note and with what gesture she will express each lyric.

The blank paper stares back at me as if to say, "Well, what are you waiting for? Draw her!"

I look around at the corkboards that surround me and try to glean any last inspiration from the "muses" I have pinned there: images of faces, each holding an inspirational spark. There are pictures of actresses, master drawings, a photo of my wife. It could be something I saw in the eyes, the mouth, her smile, that delicate nose, a grace, a spirit—often something so enigmatic I am still not sure why I pinned it up. They all call to me now.

I study the little thumbnail sketches I have made as I explored how best to communicate this particular moment in the song.

All the planning is done. Nothing stands in the way. I must begin.

As the pencil makes its first mark, a magical transformation occurs. The animation paper becomes a window and I enter into another world. The Princess I draw is alive and breathing. She tells me what she wants to do. My pencil does its best to keep up. With all the skill I have at my disposal I try to serve her wishes. She turns in space, so I must draw her head moving away in perspective, her hands rising as she gestures. "Oh, I wish I drew hands better than this. She deserves beautiful hands!"

I feel her heart longing. The melody is in my mind, and I wrestle with my artistic limitations to do justice to such emotion.

I remember the words of Eric Larson, my old animation mentor: "The secret of Disney animation is sincerity."

"Sincerity?" I wondered. "How do you draw with sincerity? Do I press harder on my pencil?" Eventually I learned he was speaking not about some technical secret but about one of the heart. He was speaking about believing in what you animate. "If you don't believe in your character," he said, "how do you expect the audience to believe in her?"

And so I lose myself in the moment, and hours pass by as though they were minutes. Hundreds of drawings remain as the record of that morning spent with a Princess.

Eventually these drawings are projected on a screen, and as they flash by at twenty-four images per second, she comes to life. The Princess takes a breath and sings.

Many years after animating Ariel, I continue to draw her, doodling as I talk on the phone, absent-mindedly passing time in a sketchbook. She has become a part of me and yet now belongs to the world and generations to come.

This book is a celebration of the heroic young ladies known as Disney Princesses. It is a delight to see them portrayed in such varied artistic styles and interpretations by such a gathering of talented artists.

In closing, I would like to acknowledge the Disney animators who over the years have spent similar mornings with their own Princesses: Grim Natwick, Ham Luske, Marc Davis, Milt Kahl, Eric Larson, Frank Thomas, Ollie Johnston, Mark Henn, James Baxter, Andreas Deja, Ken Duncan, and Randy Haycock.

— Glen Keane
Disney Animator

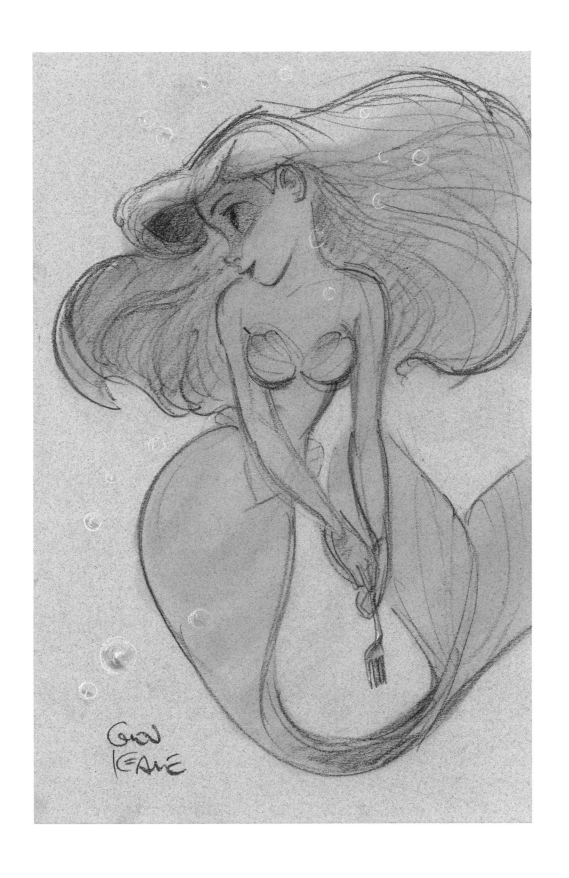

Ariel
Glen Keane
Conte crayon on pastel paper

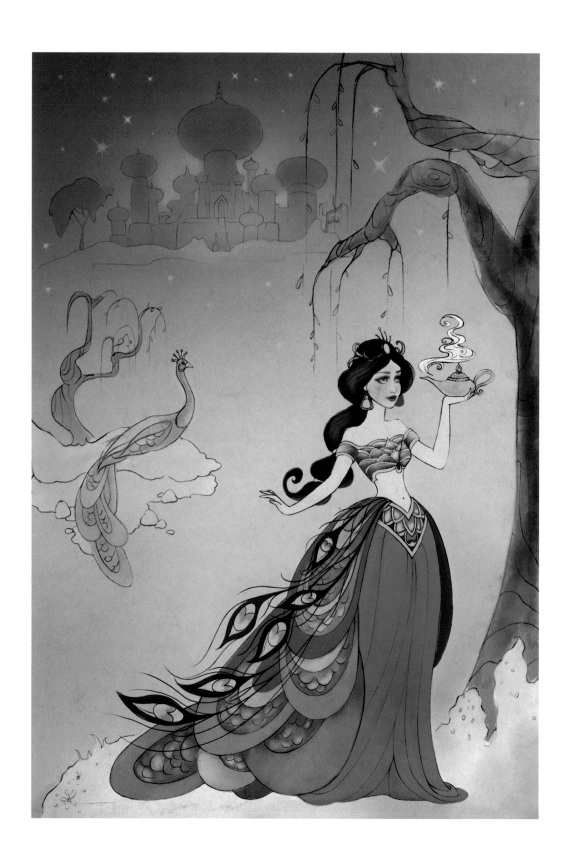

Jasmine
Stacey Aoyama
Acrylic and digital media

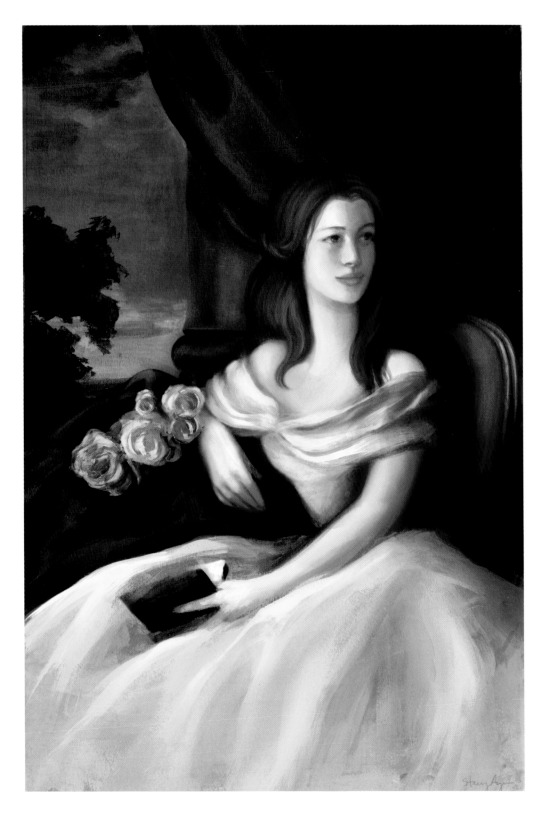

Belle
Stacey Aoyama
Acrylic and digital media

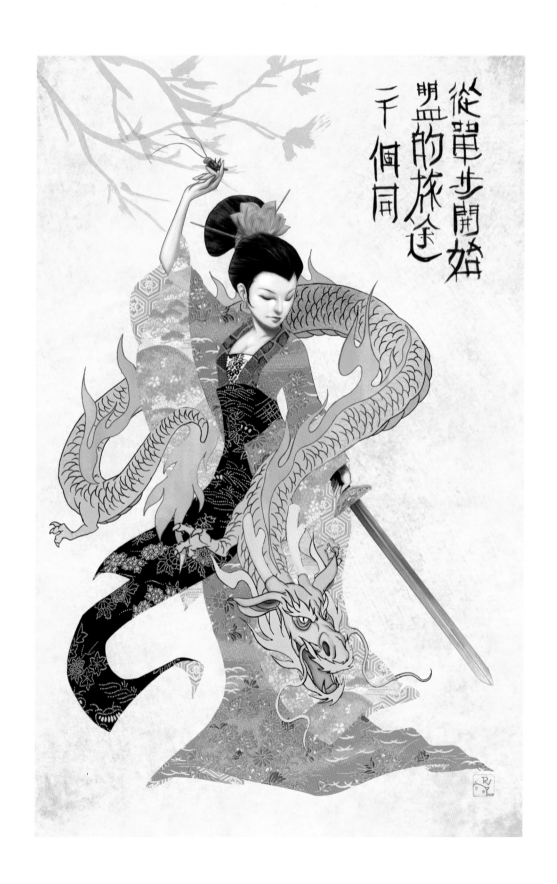

Mulan
Ron Velasco
Watercolor, origami paper, graphite, and digital media

I chose Mulan because her tale is one of epic heroism. Mulan's heroism is evoked through her defiance of traditional gender roles and her personal growth. The film also illustrates the importance of family, community, and teamwork. I used a combination of traditional and digital painting and incorporated collage patterns. Mulan is posed in a traditional dress with Mushu wrapped around her in a protective way, and she holds the lucky cricket in her hand. I wanted her pose to convey confidence and also show her delicate femininity and the sophistication of a Chinese woman. My inspiration came from traditional watercolor Chinese paintings. These paintings usually consisted of decorative patterns and designs created with a brush drawing technique similar to that of calligraphy. They were typically painted on scrolls and were mainly used for protection against evil spirits, for the depiction of history, and for ancestral portraiture.

Ron Velasco

Snow White

8

Jeff Shelly

Watercolor, gouache. and digital media

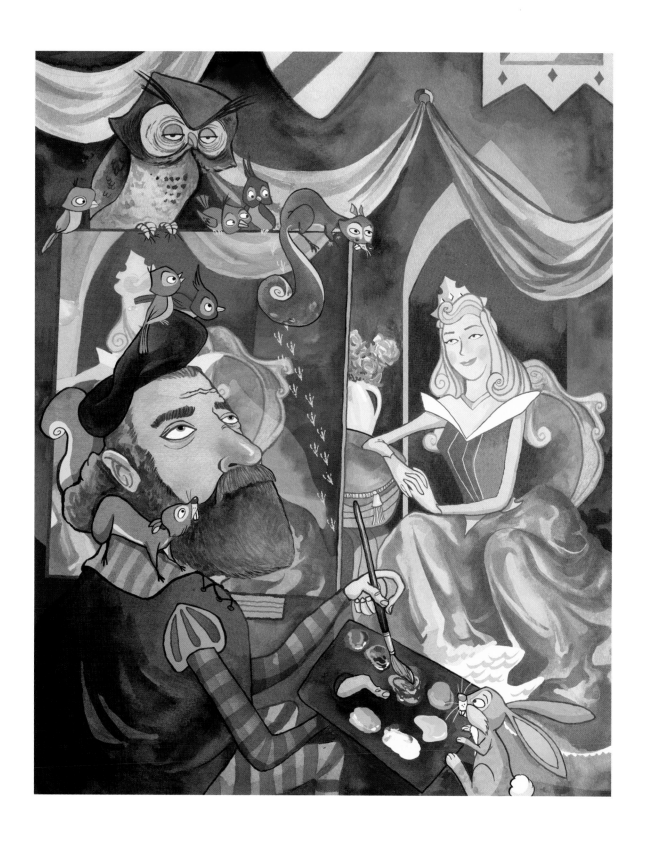

Aurora
Jeff Shelly
Watercolor, gouache, and digital media

⚜
9
⚜

Aurora
10
Eli Trinh
Digital media

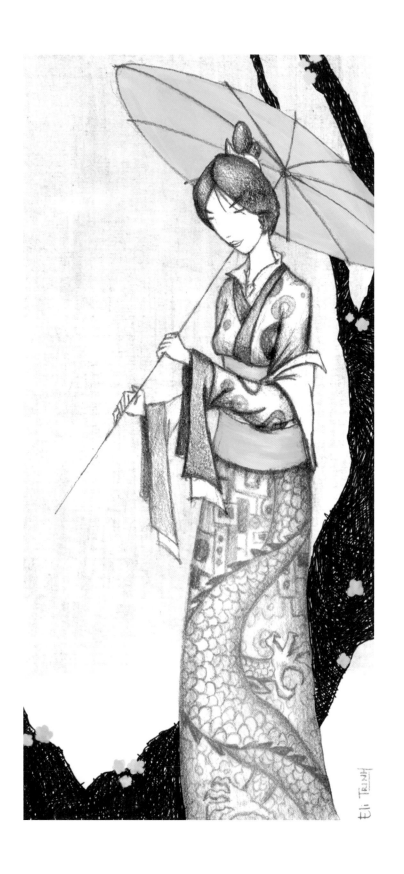

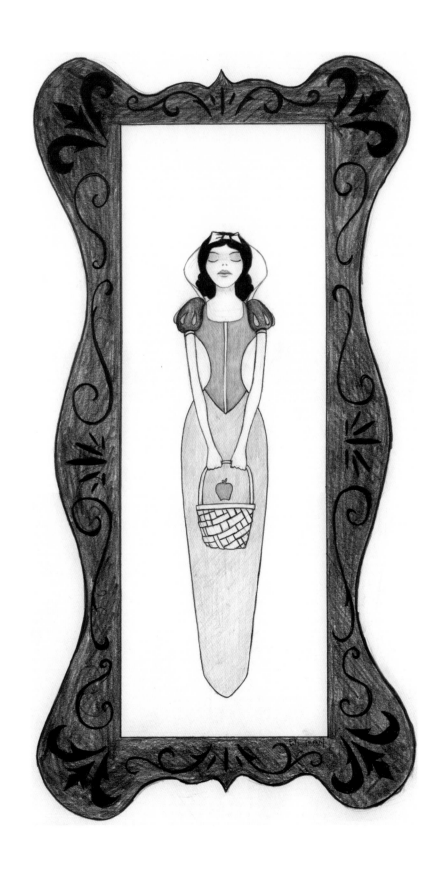

Snow White

12

Eli Trinh

Pencil on paper

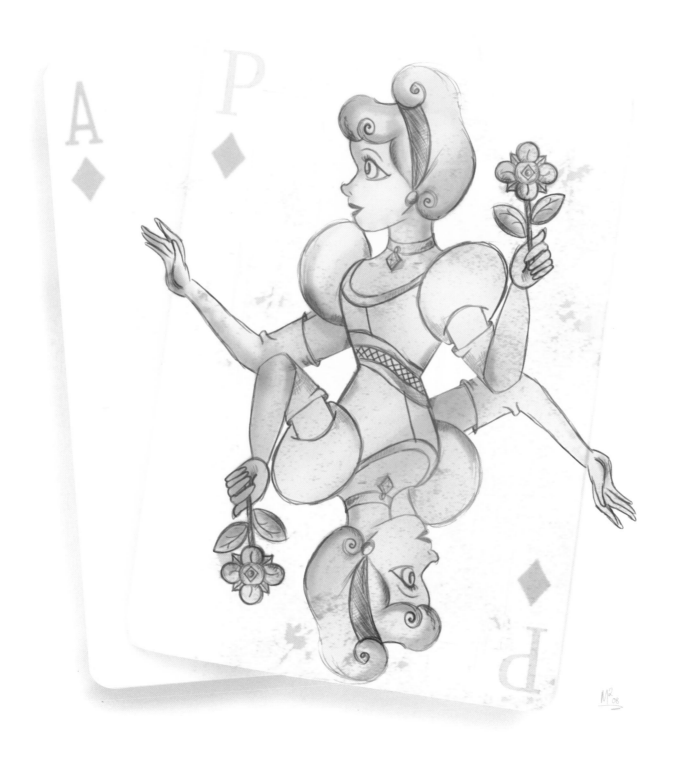

Cinderella
Marisa Morgan
Digital media

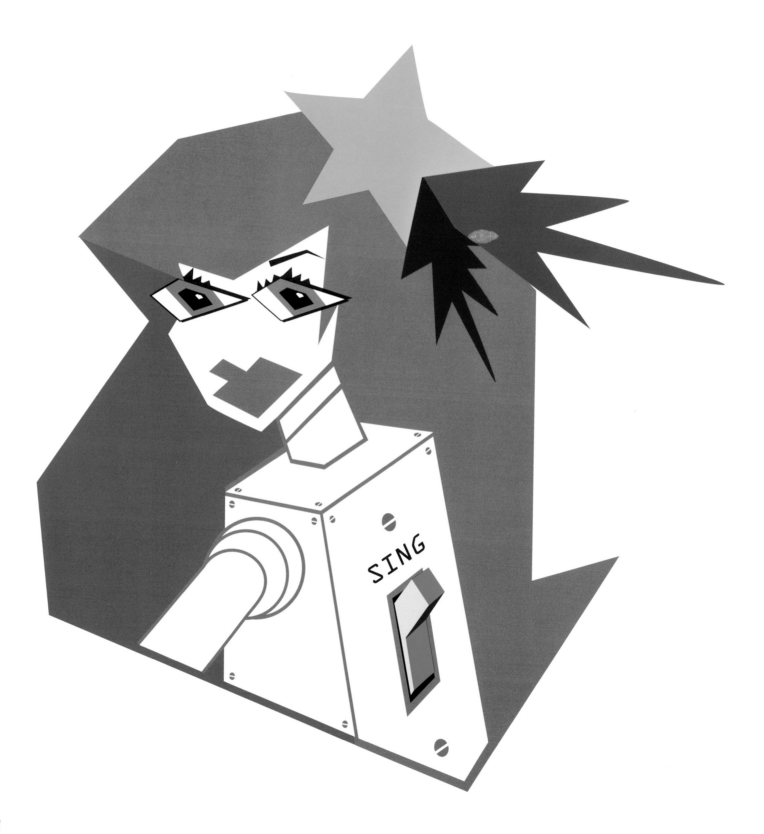

Ariel
14
Linda Ra
Digital media

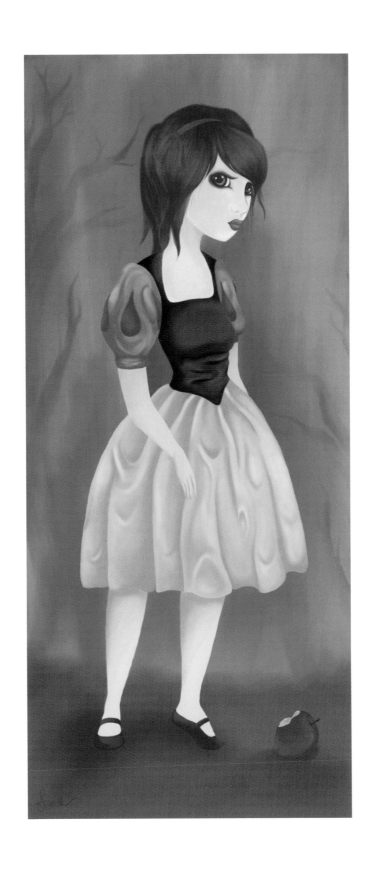

Snow White
Aimee Anievas
Digital media

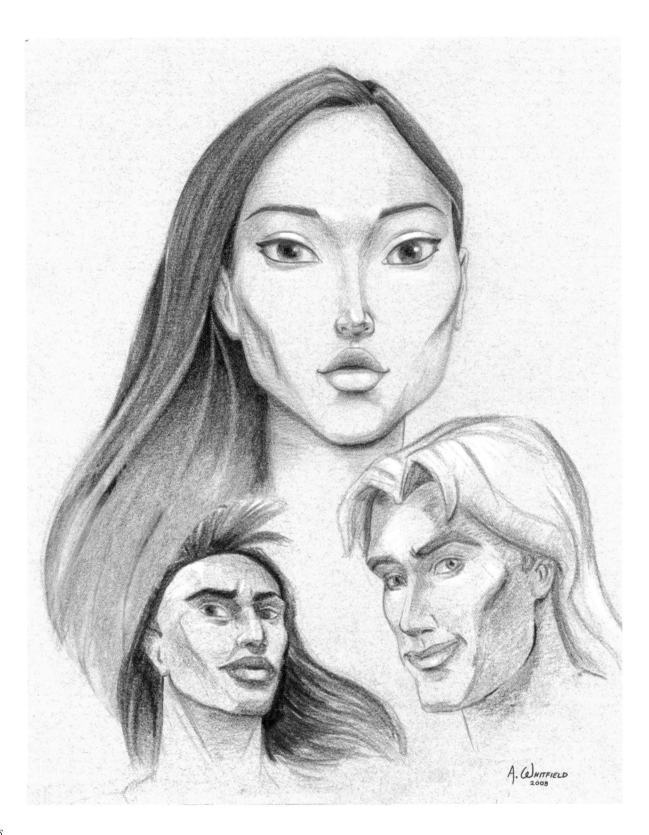

Pocahontas
Anthony Whitfield
Pencil on toned paper

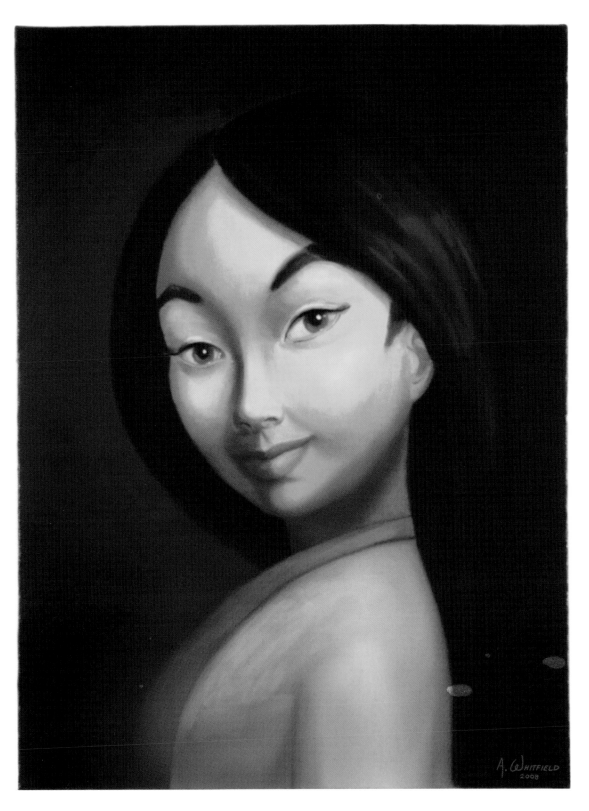

Mulan
Anthony Whitfield
Oil on canvas board and digital media

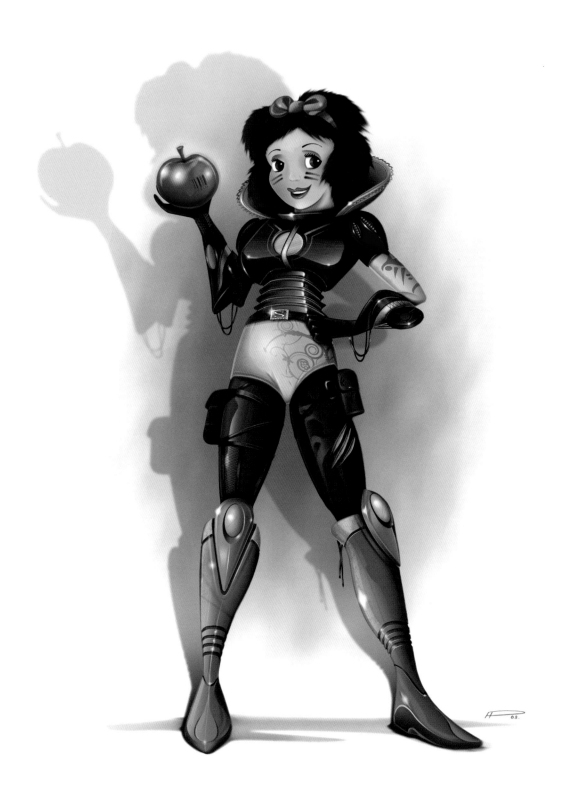

Snow White
18
Alpesh Patel
Digital media

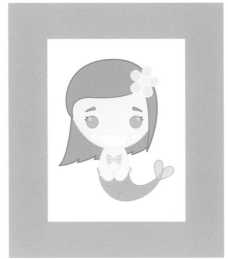 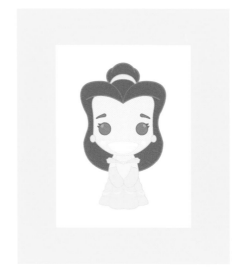

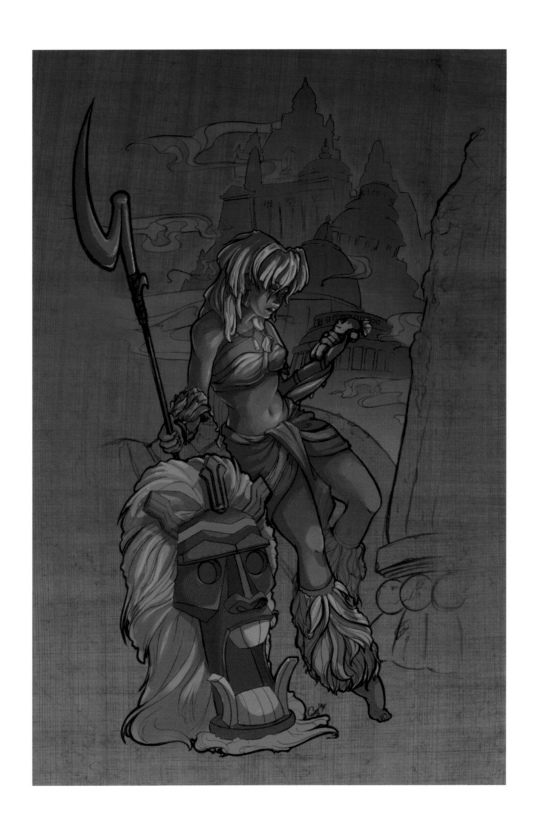

Kida
20
Cathy Clark
Digital and mixed media

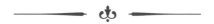

I love art nouveau and artists like Alphonse Maria Mucha, who really created this sense of movement and life in their compositions. George Petty, too, influenced how I look at backgrounds. He had a brilliant way of being able to give enough information for the viewer to be able to set the scene, without distracting from the main subject. I chose Kida because *Atlantis* is such a visually beautiful film, and Kida as a Princess is somewhat unique. She's not just called a Princess; as an audience, we actually get to see her really take on the responsibility that the job entails, physically protecting her people, and in many instances, making hard personal sacrifices for their sake. I also chose Tiger Lily, because she is one of those Princesses often forgotten, but she's such a fun character. For the short time she is on screen, her animation is nicely done, and her design really reflects that great 1950s aesthetic. Princess Tiger Lily is an integral part of the story, but she watches from the sidelines through much of *Peter Pan*. It seemed somewhat fitting that she be watching events indirectly, as reflected through the island itself.

Cathy Clark

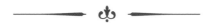

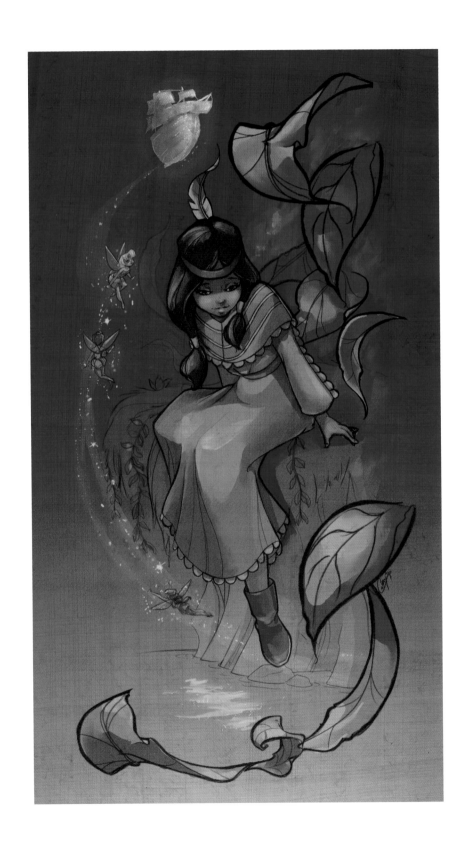

Tiger Lily
22 Cathy Clark
Digital and mixed media

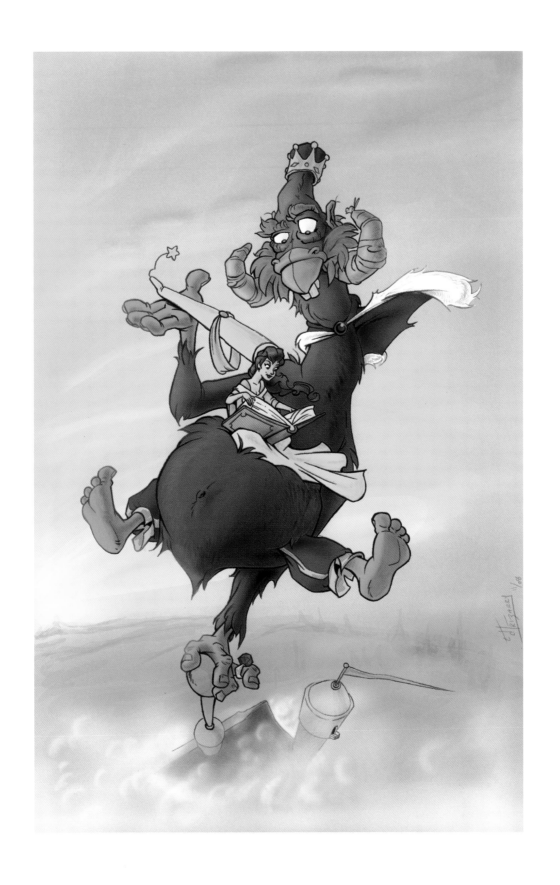

Like to try one?

Snow White
Enrico Soave
Photography and digital media

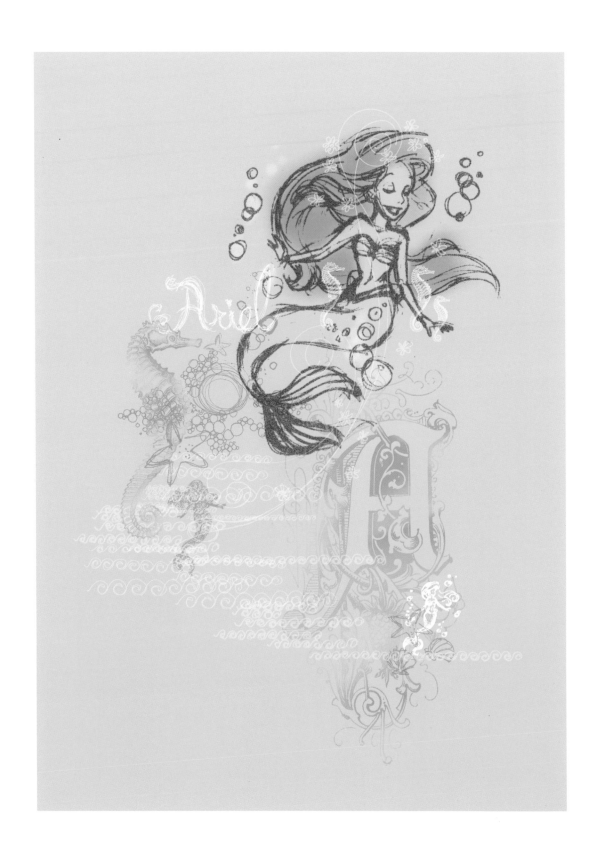

Ariel
Dan Beltran
Pen, ink, and digital media

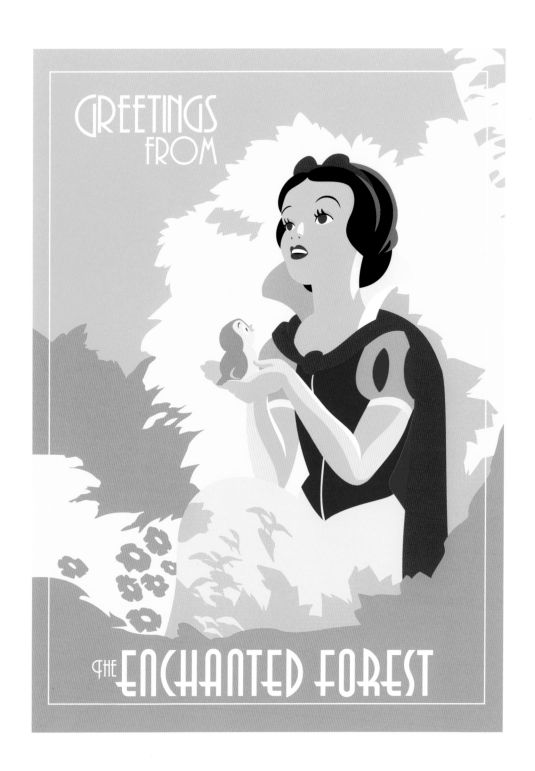

GREETINGS FROM

THE ENCHANTED FOREST

Snow White
26
Dan Beltran
Pencil and digital media

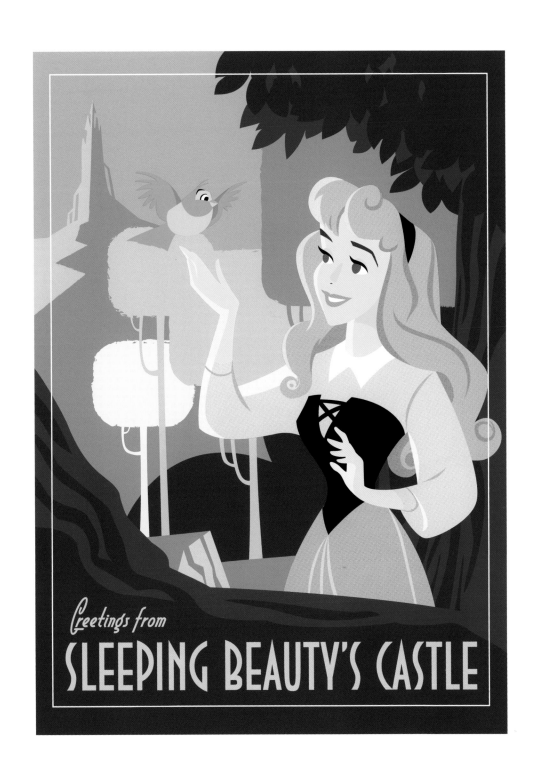

Aurora
Dan Beltran
Pencil and digital media

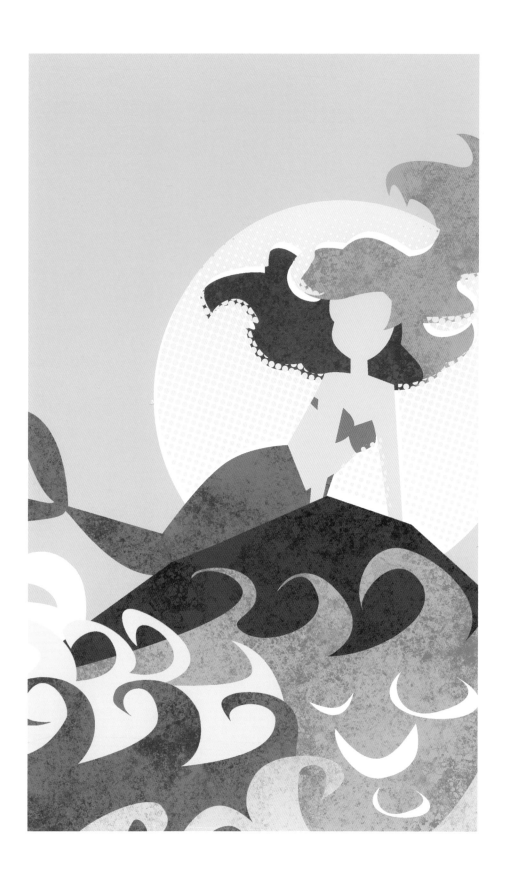

Ariel
28 Dan Beltran
Pencil and digital media

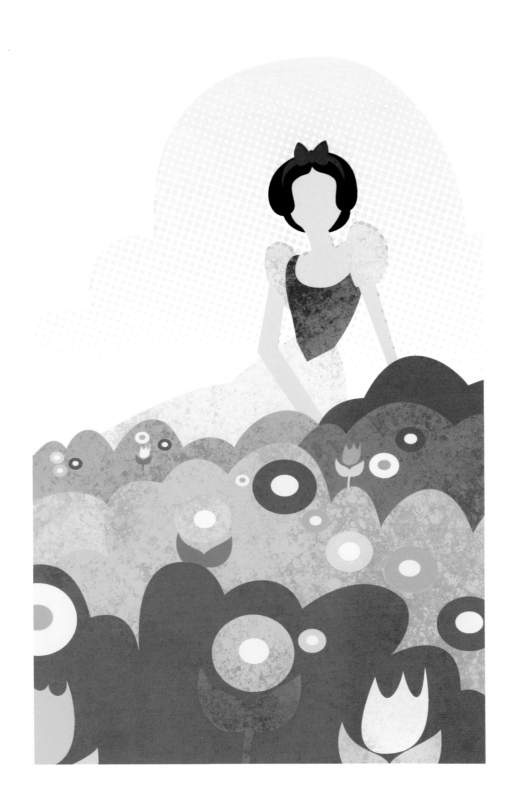

Snow White
Dan Beltran
Pencil and digital media

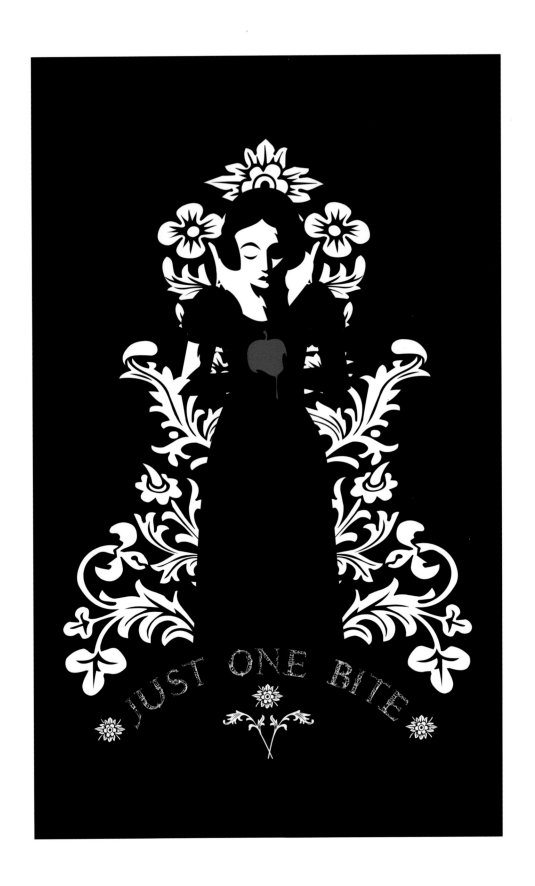

Snow White
30
Dan Beltran
Pencil and digital media

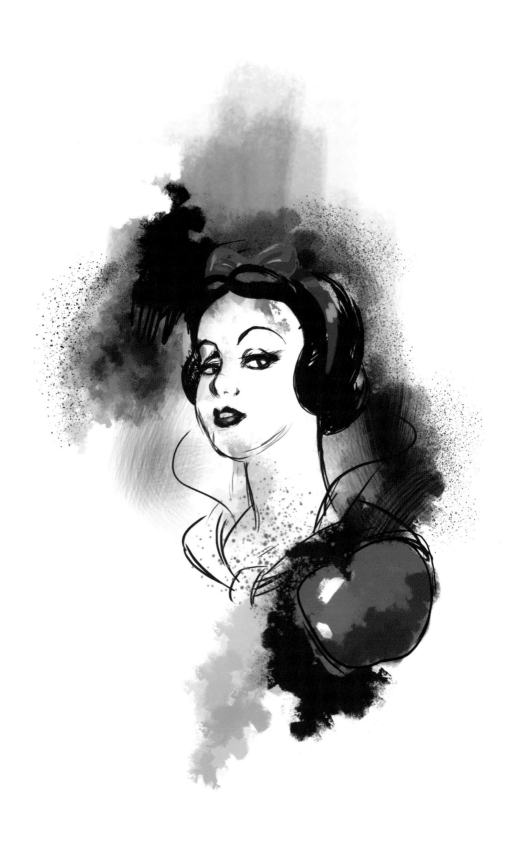

Snow White
Dan Beltran
Digital media

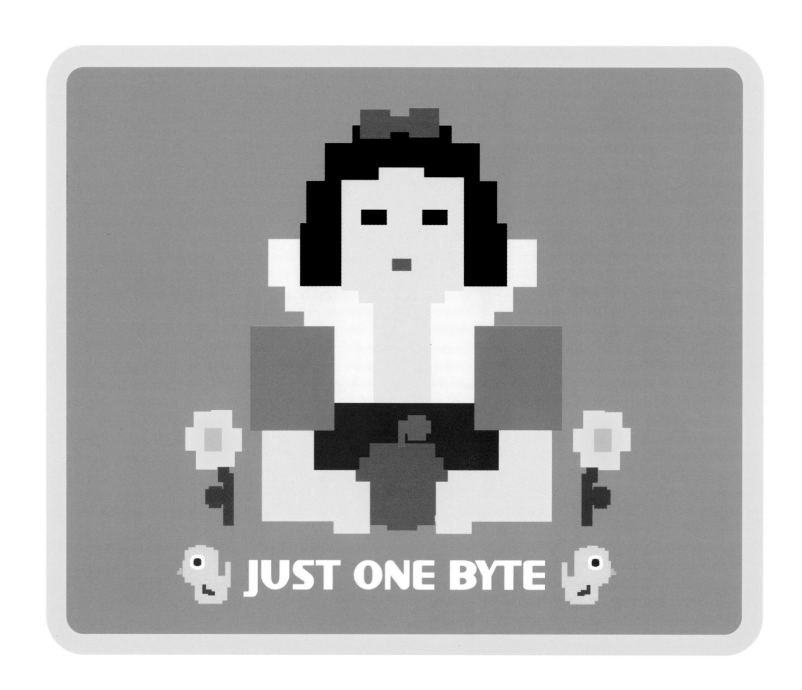

Snow White
32 Dan Beltran
Pencil and digital media

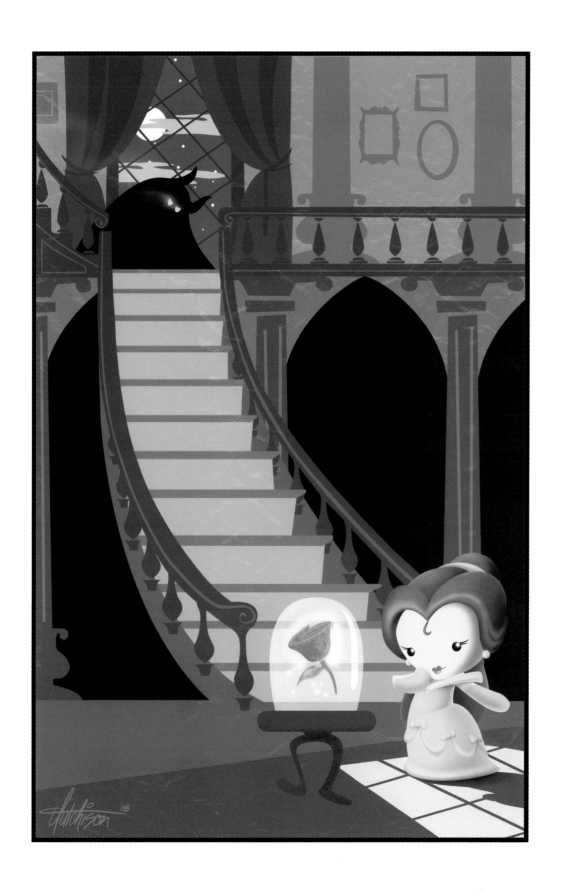

Belle
Eric Hutchison
Digital media

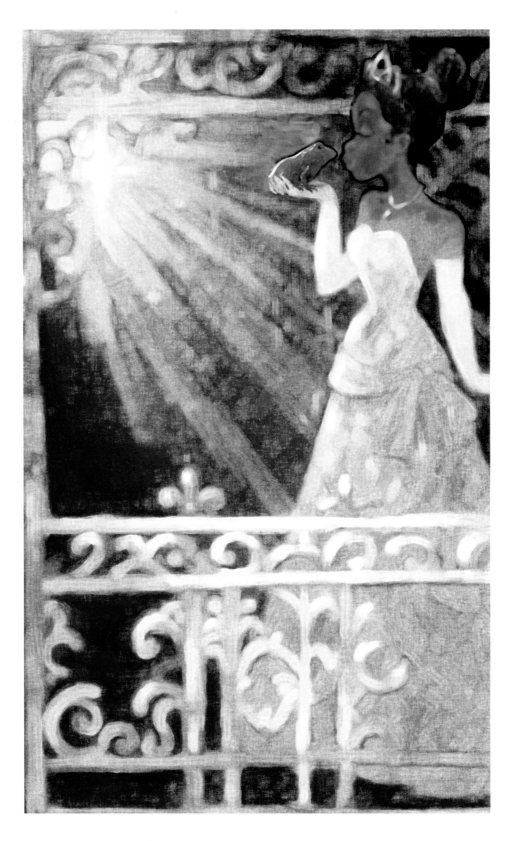

Tiana

34

Dorota Kotarba-Mendez

Soft pastel and digital media

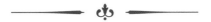

Each morning when I wake, I dress in my ball gown and glass slippers and travel by horse-drawn carriage to a palace on a hilltop in a fairy-tale kingdom. Actually, it's an office building in Glendale, California, but it is pretty magical. It is a fairy tale come true for me to work in the world of the Disney Princess. Each day, I am privileged to create new art featuring Cinderella, Ariel, Snow White, and all of the other Disney Princesses. This year is very exciting as we introduce our newest Princess, Tiana, from Disney's *The Princess and the Frog*. It has been thrilling to learn about this new character from Mark Henn, the Disney animator who brought Tiana to life. Taking as inspiration the colors and architecture of the French Quarter in New Orleans, I decided to celebrate Tiana in this somewhat impressionistic piece. I began with the traditional medium of soft pastels on paper to establish the play of light and color without the delineation common to animated cartoons. I completed the image using digital media and a little bit of pixie dust.

Dorota Kotarba-Mendez

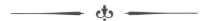

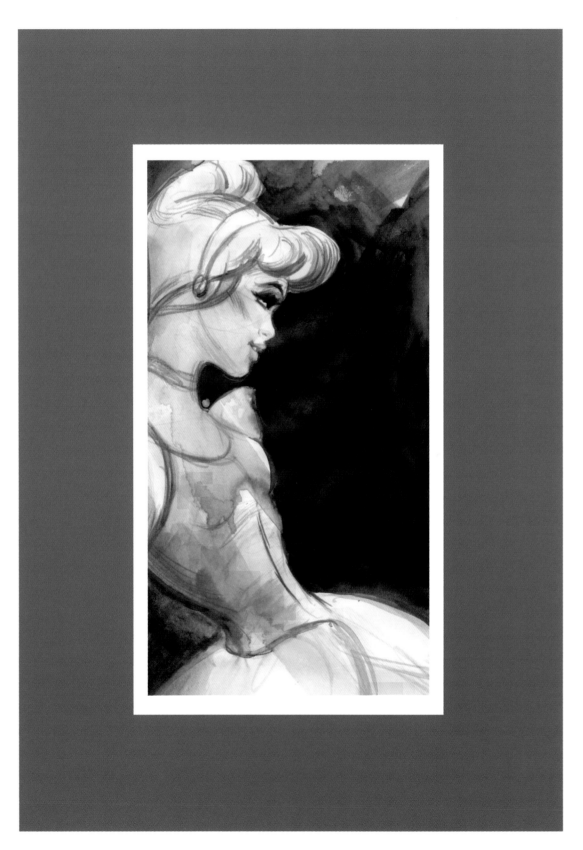

Cinderella
Dorota Kotarba-Mendez
Ink drawing and ink wash

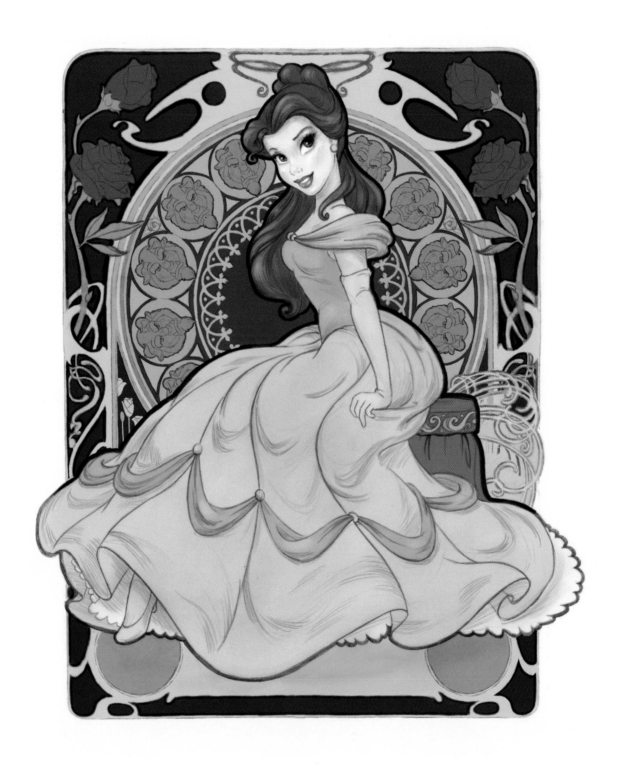

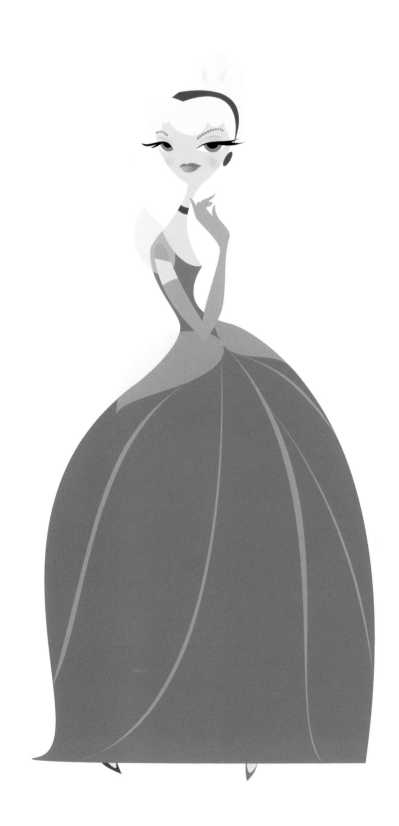

Cinderella
38
Dorota Kotarba-Mendez
Digital media

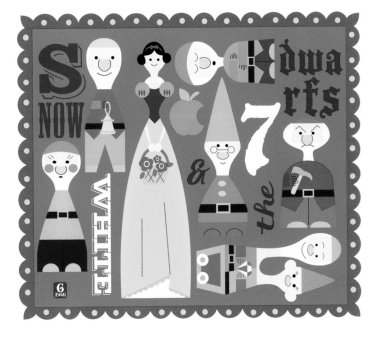
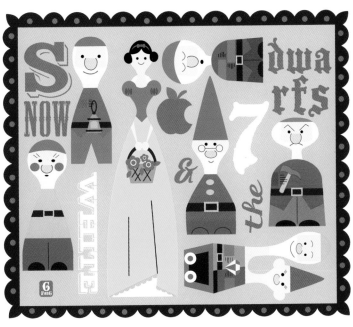
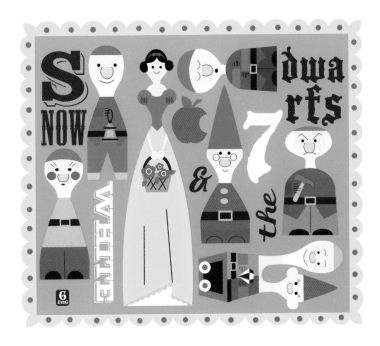

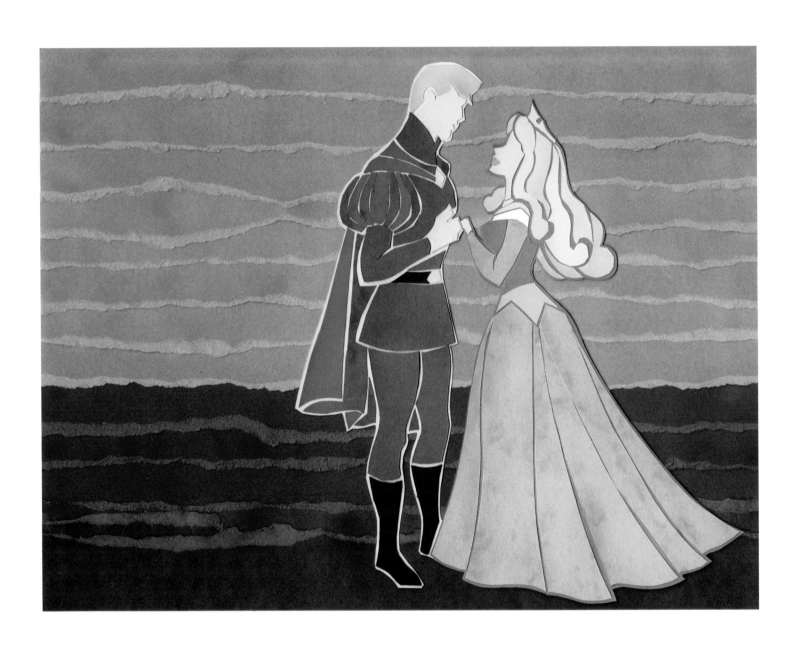

Aurora
40
Beki Phinney
Paper collage

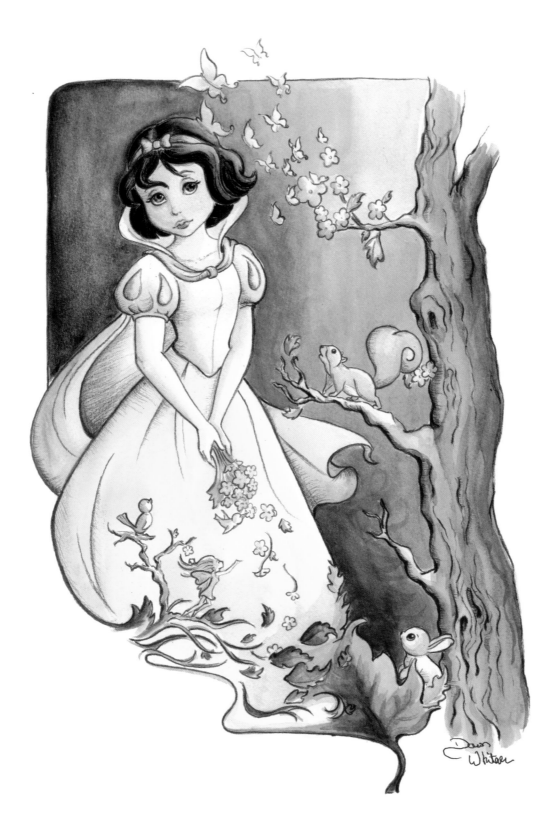

Snow White
Dawn Whitaker
Watercolor and colored pencil

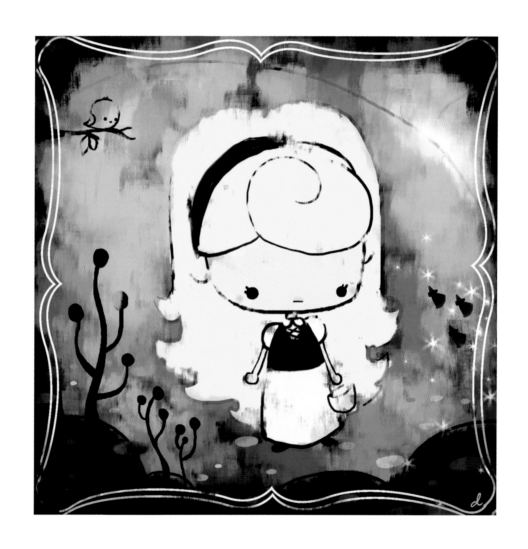

Aurora

Diana Shin

Digital media

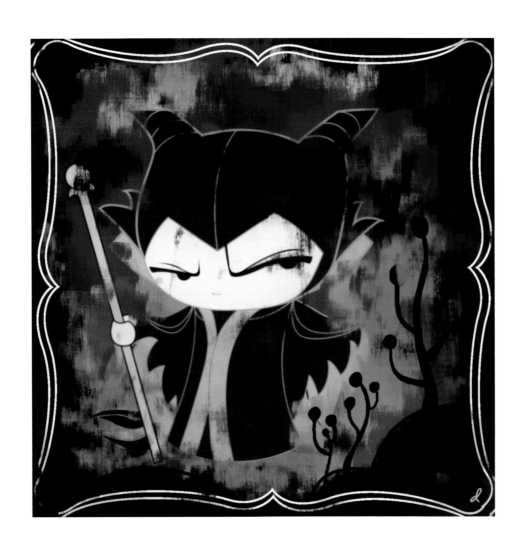

Maleficent
Diana Shin
Digital media

Snow White in Griffith Park

Ariel, Hitchcock Park

Princesses
Danielle Bedics
Photography and mixed media

Ariel at Santa Monica Pier

Cinderella at Walt Disney Concert Hall

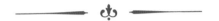

I was inspired by the style of art nouveau painter Alphonse Maria Mucha; I thought this look would be classic and innovative, and it has never been done before.

Enrique Pita

I felt that it would be a perfect fit to create the Princesses in this style of beauty and elegance. These pieces capture the heart of each of the characters.

Ed Irizarry

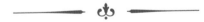

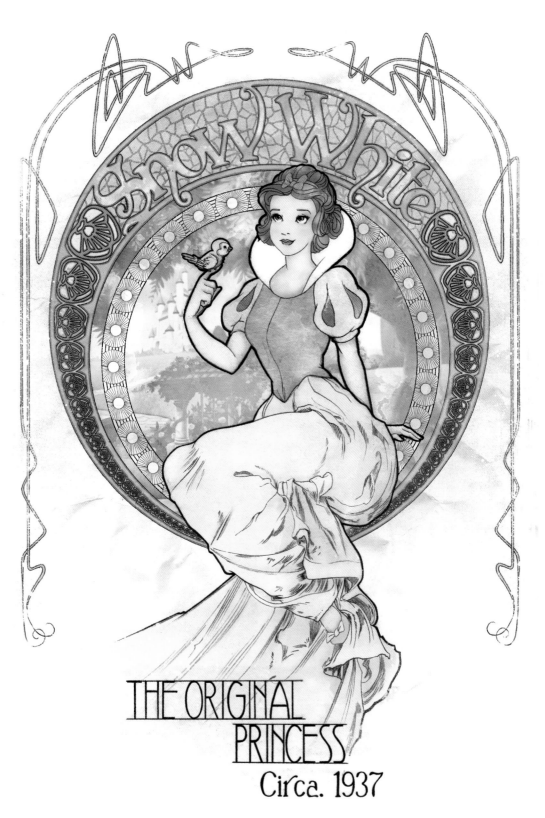

Snow White
Enrique Pita and Ed Irizarry
Pencil and digital media

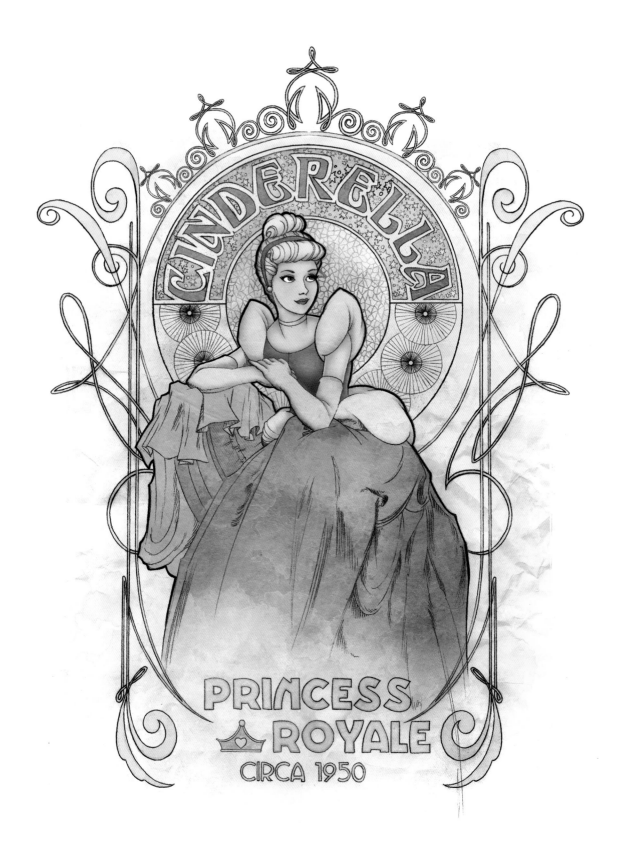

Cinderella

Enrique Pita and Ed Irizarry

Pencil and digital media

AURORA

CIRCA ·1959·

THE DREAM PRINCESS

Aurora
Enrique Pita and Ed Irizarry
Pencil and digital media

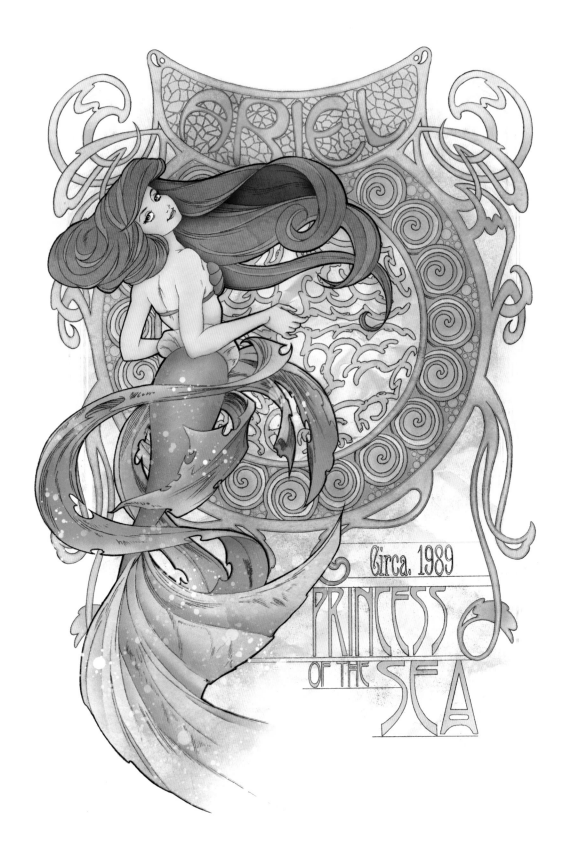

Ariel

Enrique Pita and Ed Irizarry

Pencil and digital media

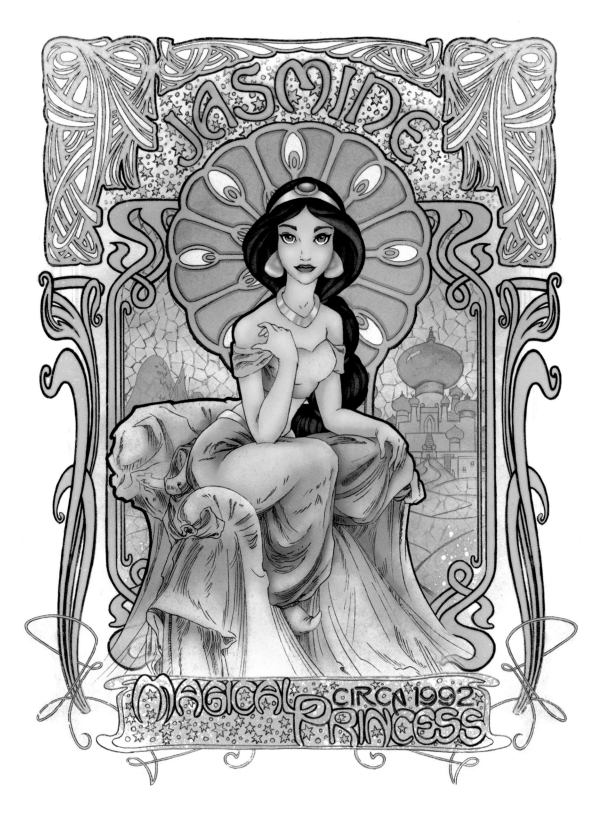

Jasmine
Enrique Pita and Ed Irizarry
Pencil and digital media

Mulan
52
Ellie Choi-Huezo
Digital media

Cinderella
Ellie Choi-Huezo
Digital media

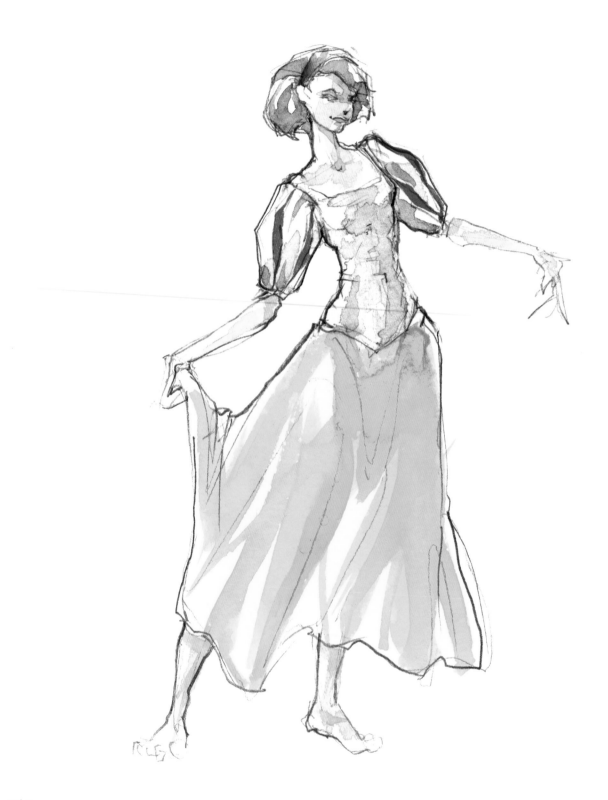

Snow White
Ed Duncan
Pencil and watercolor on paper

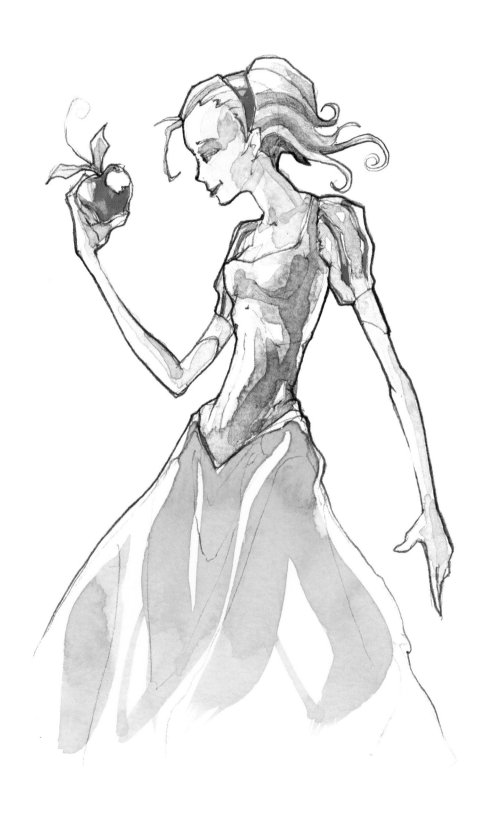

This snow white was inspired by kokeshi
(a traditional japanese wooden doll)

Kokeshi has invited japanese girls to dream
through generations.

Tokie Esaka
Disney Brazil

once upon a time

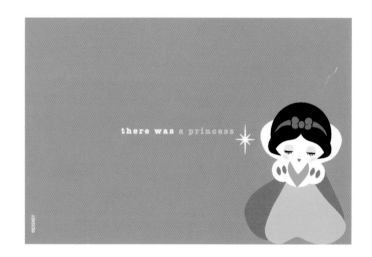

there was a princess

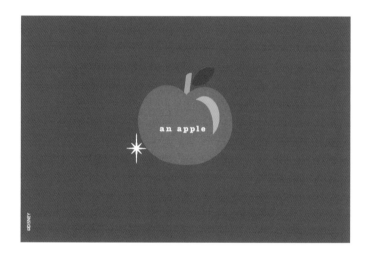

an apple

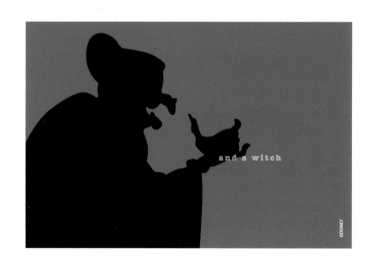

and a witch

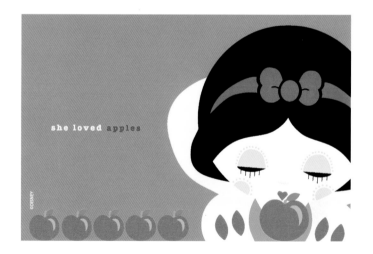

she loved apples

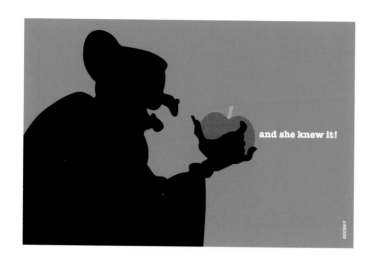

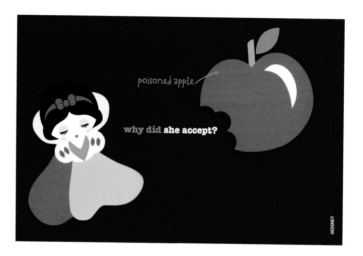

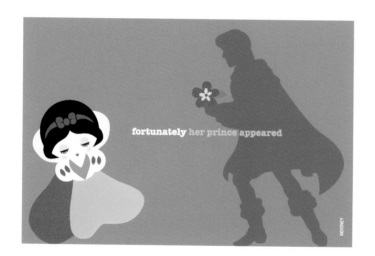

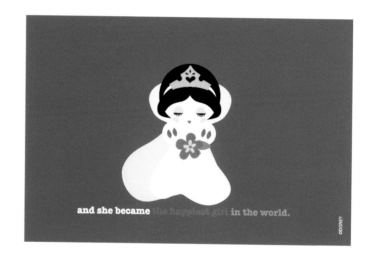

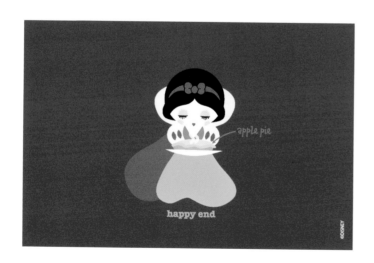

With these two pieces, I really tried to capture the light and dark within each Princess story. On the bright side is Ariel, whose film *The Little Mermaid* reinvigorated the studio and inspired me while I was in school to rediscover all the classic Disney films I loved as a kid. One of those films was *Sleeping Beauty*. As an adult, I have far more of an appreciation for the artistic style of the film. It was also a complex story with dark, dramatic moments and a cast of memorable characters that I felt would lend themselves perfectly to an old-fashioned epic film poster. Both pieces were done digitally.

Eric Tan

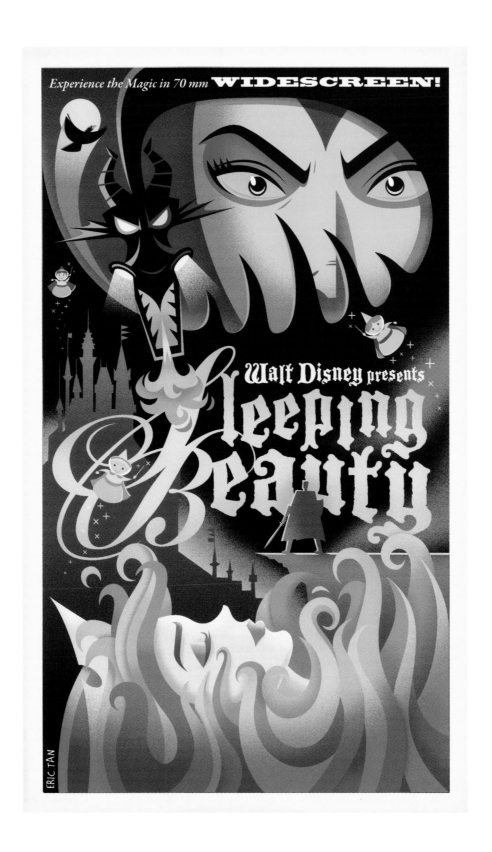

Experience the Magic in 70 mm **WIDESCREEN!**

Walt Disney presents

Sleeping Beauty

ERIC TAN

Aurora
Eric Tan
Digital media

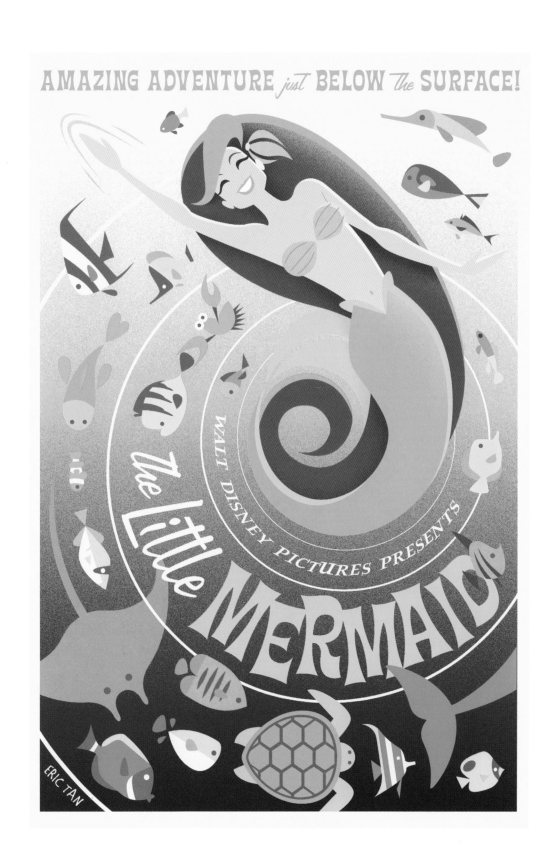

Ariel
Eric Tan
Digital media

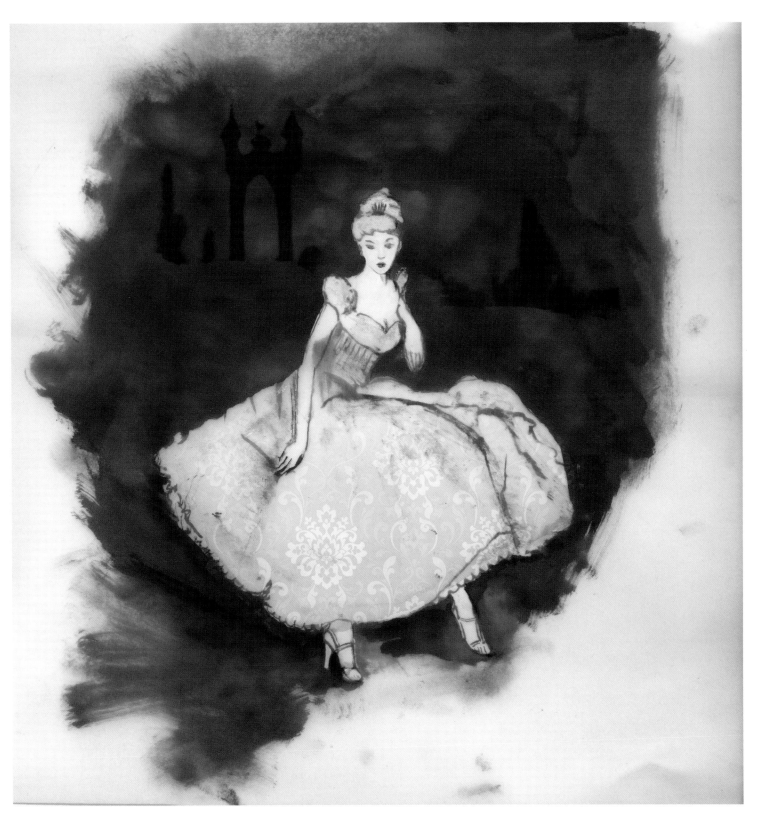

Cinderella
Janet Wilson-Theobald
Ink on paper

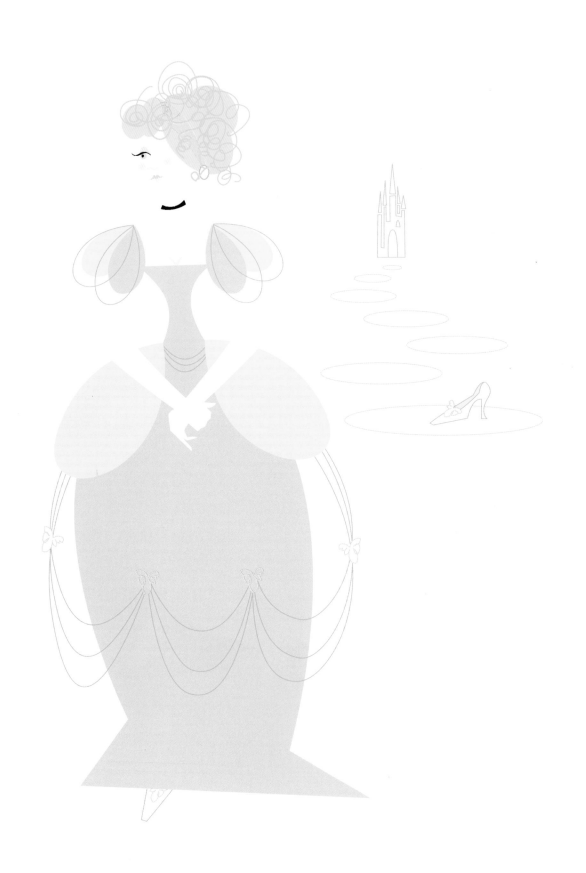

Cinderella

62 Frac Fox

Digital media

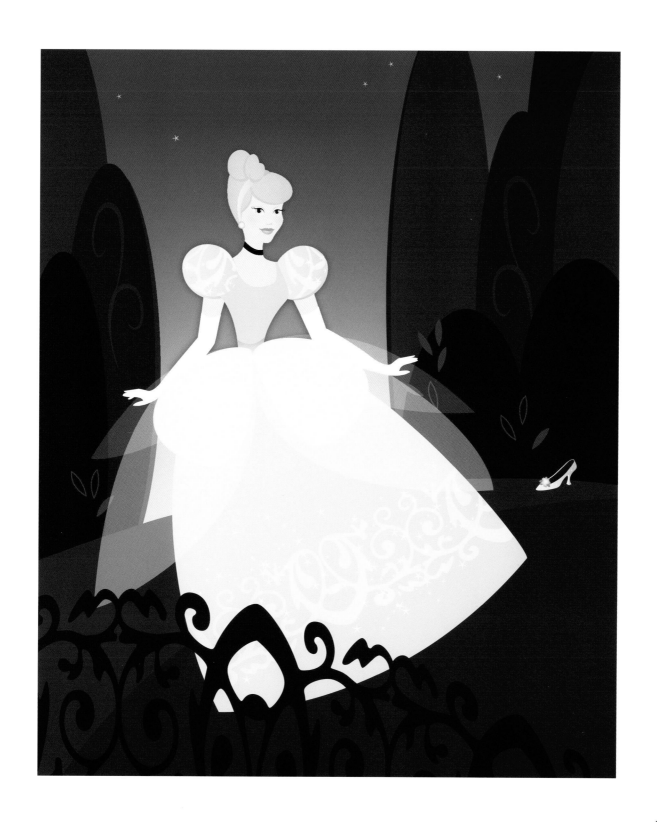

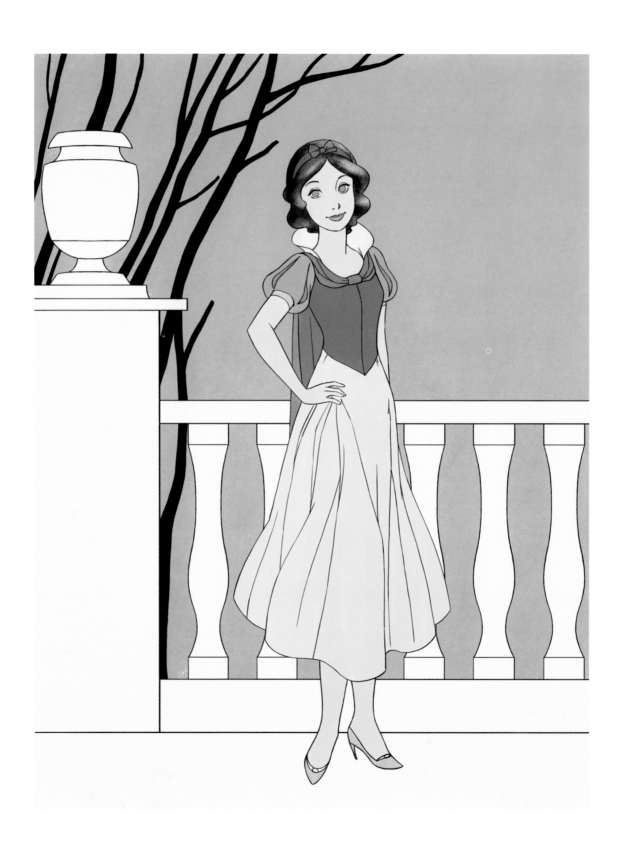

Snow White
64
Frederic Danel
Digital media

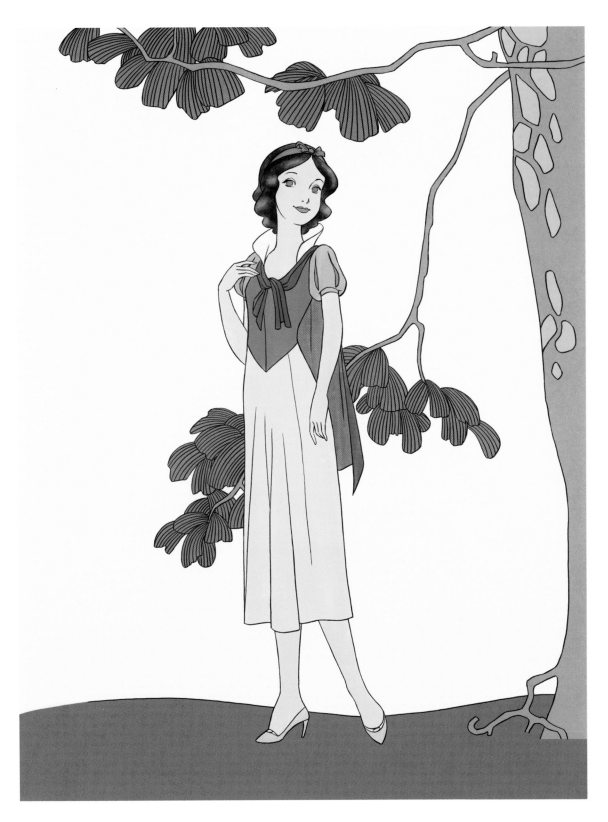

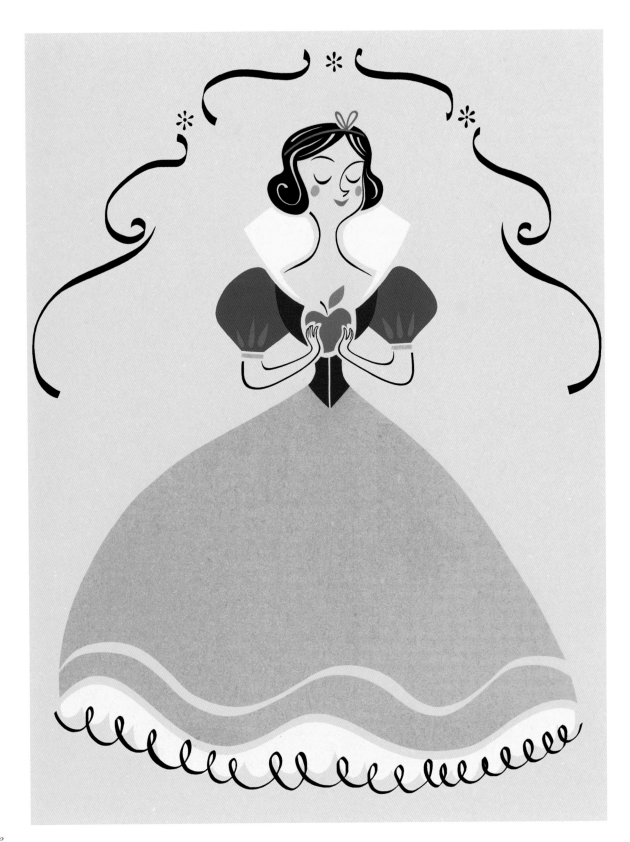

Snow White

66

Genevieve Godbout

Digital media

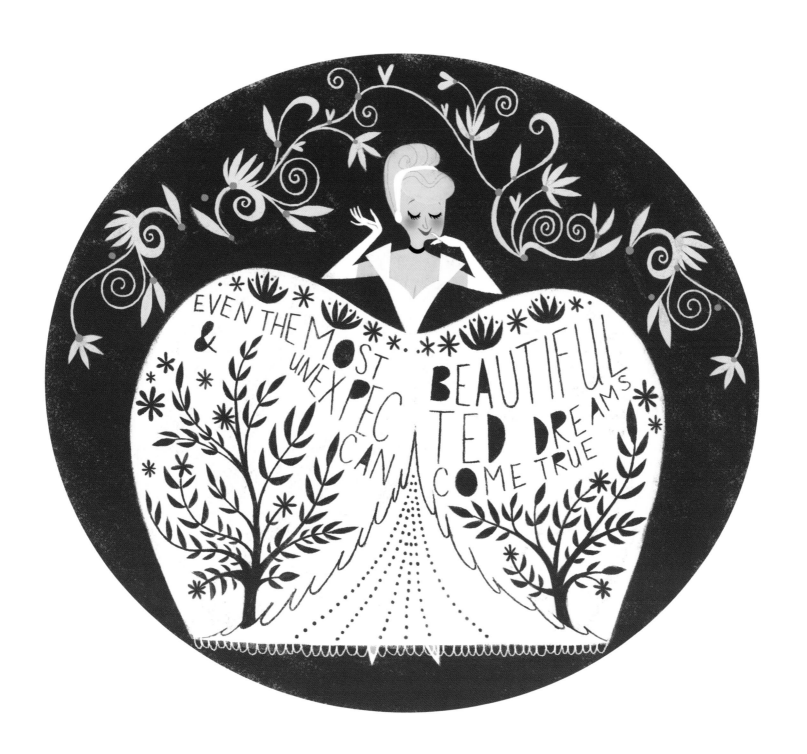

Cinderella
Genevieve Godbout
Digital media

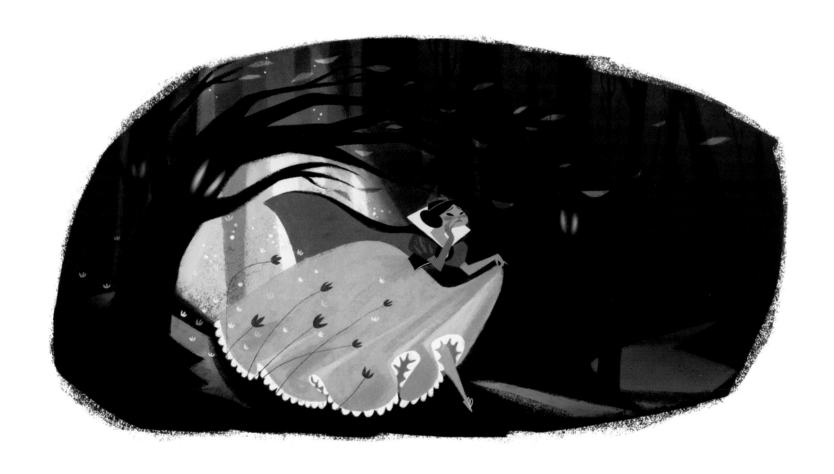

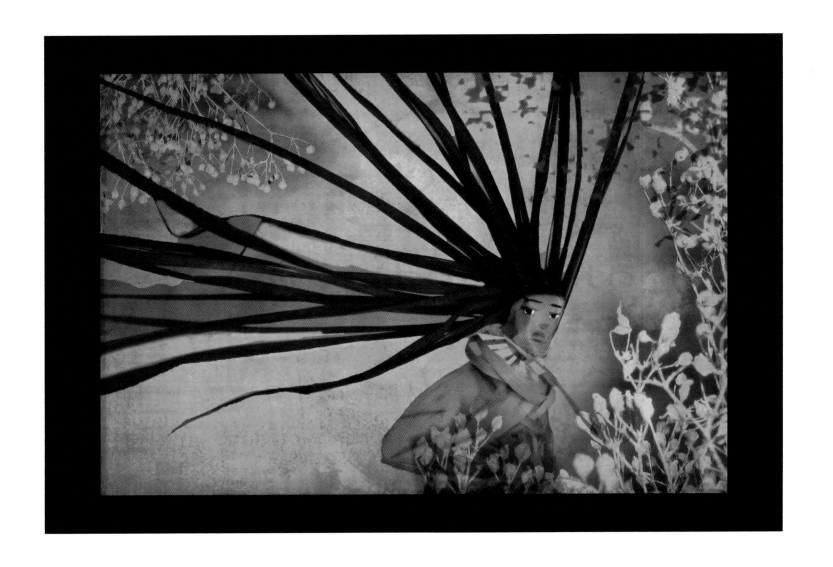

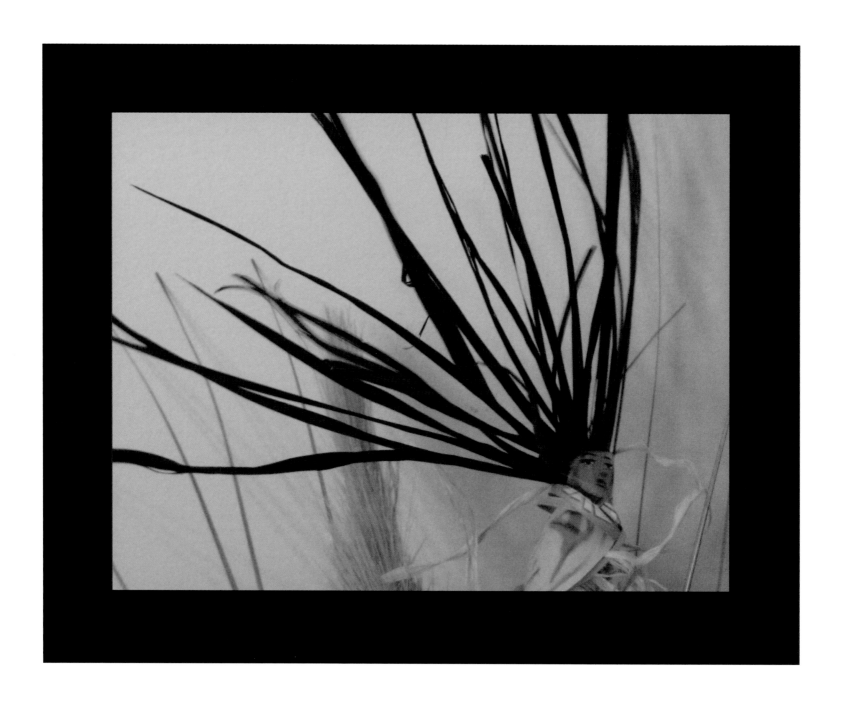

Pocahontas

70

Caroline LaVelle Egan

Dead grass, glue, sticky tape, twine, cut paper, a branch, and digital media

One calamitous autumn afternoon, I entered a prominent craft shop. I wanted to build a Princess out of silk flowers, but was not sure of which Disney Princess to choose. I had brought my camera to capture and collect ideas, but as I snapped a myriad of photographs, I was caught, red-handed, taking pictures of a harvest bouquet. Inculpated in front of numerous onlookers, I was to be punished by banishment from the store unless I deleted the pictures, stored my camera, and, of course, purchased the bouquet. I dutifully obeyed and paid for the flowers. As I left the store, my inspiration was stirred by the bereavement of life's bouquet in the declining sunshine of that October day. I observed a brilliant color palette within that withered tuft. Rusted oranges, warmed yellows, varied sepia, and deep burgundy—at last, I knew which Princess was right. From this perished posy, I started to create a doll. Burnt umber blades of grass for her hair; spun twine wound upon a birch branch for her body, and, for her face, an illustration on parchment paper. Hence, a Princess was born: my Pocahontas.

Caroline LaVelle Egan

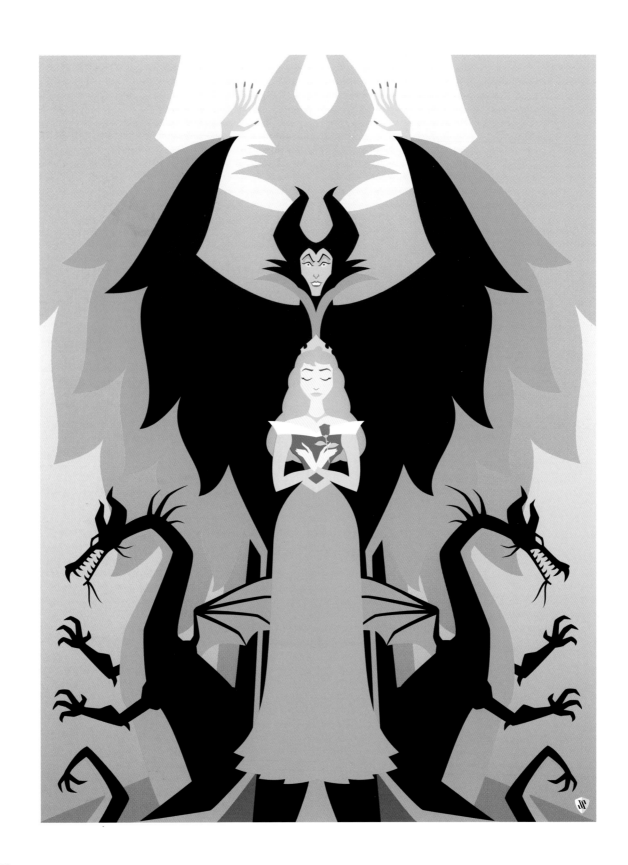

Aurora
72
Greg Storey
Digital media

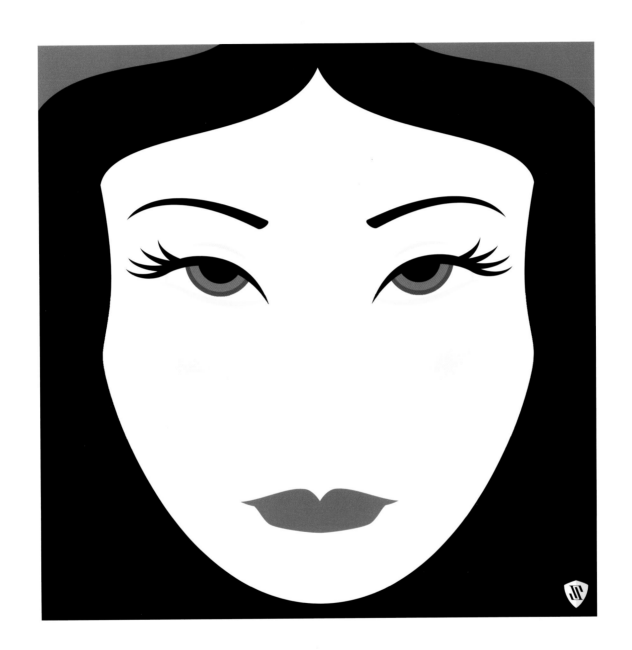

Snow White
Greg Storey
Digital media

73

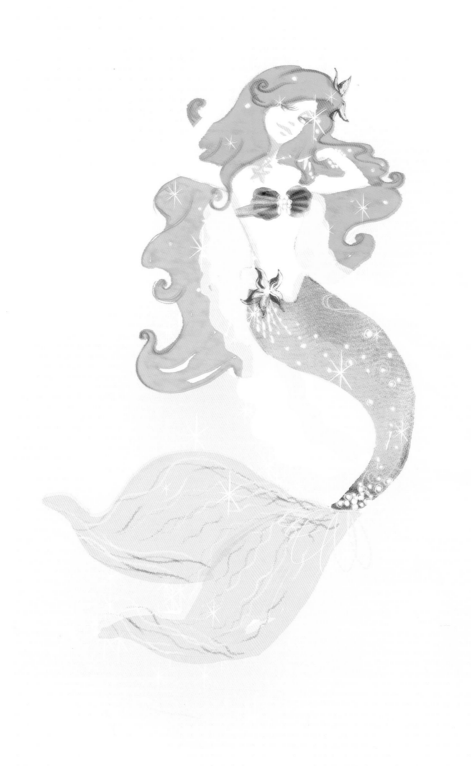

Ariel
Jaime Tracht
Digital media

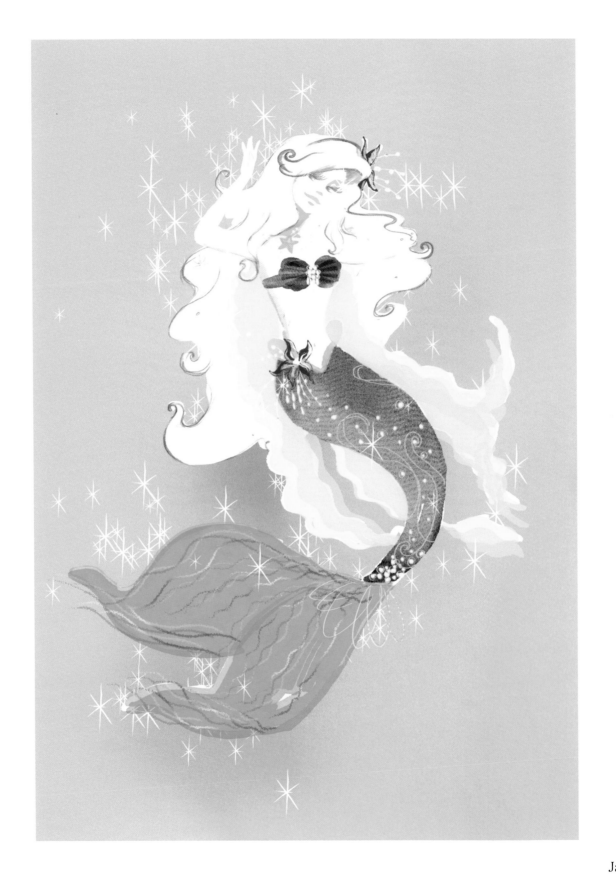

Ariel
Jaime Tracht
Digital media

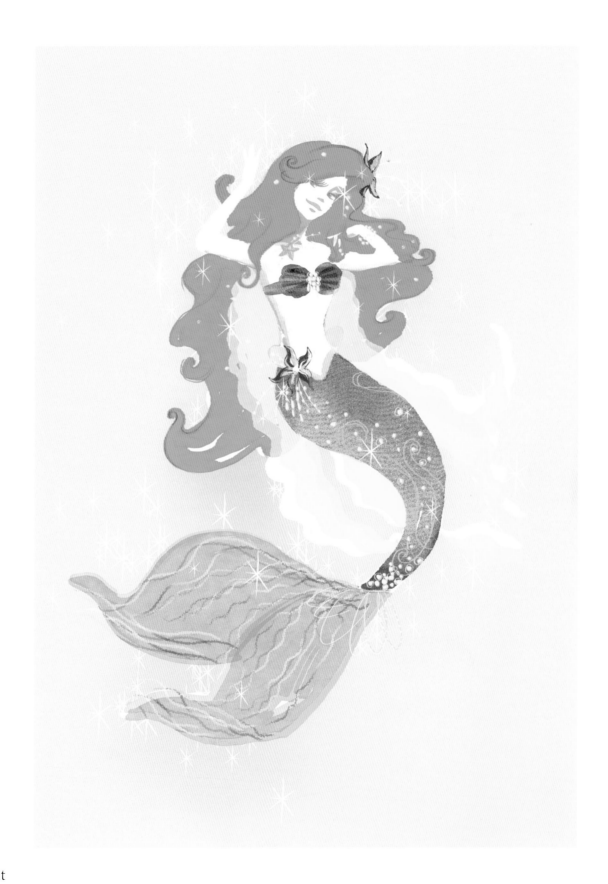

Ariel
Jaime Tracht
Digital media

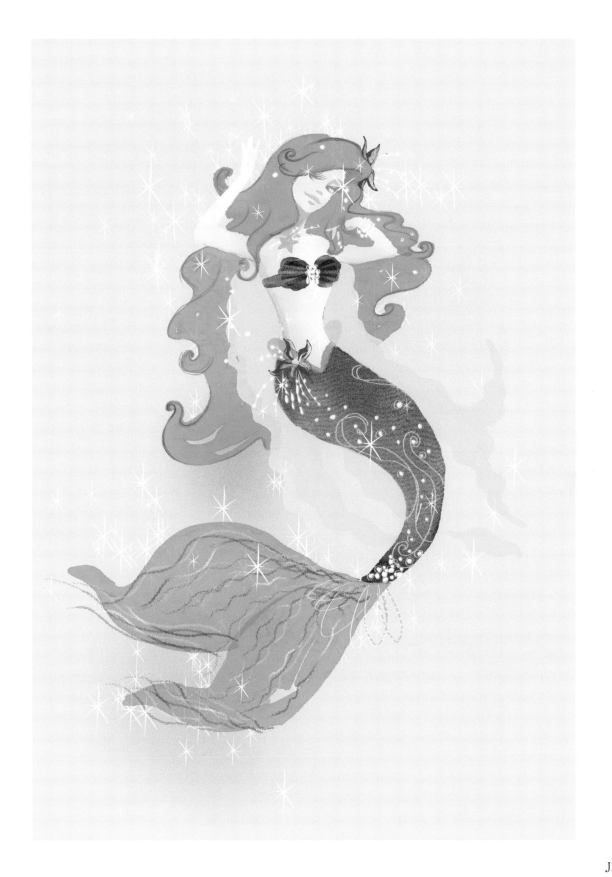

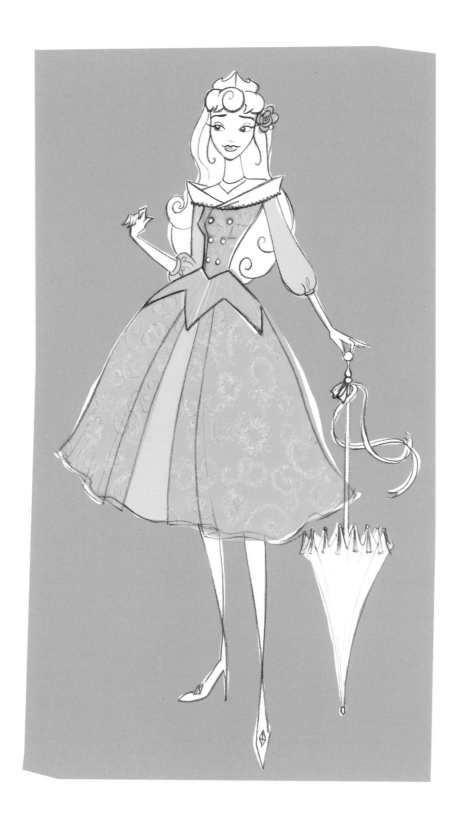

Aurora
80
Jaime Tracht
Colored pencil and digital media

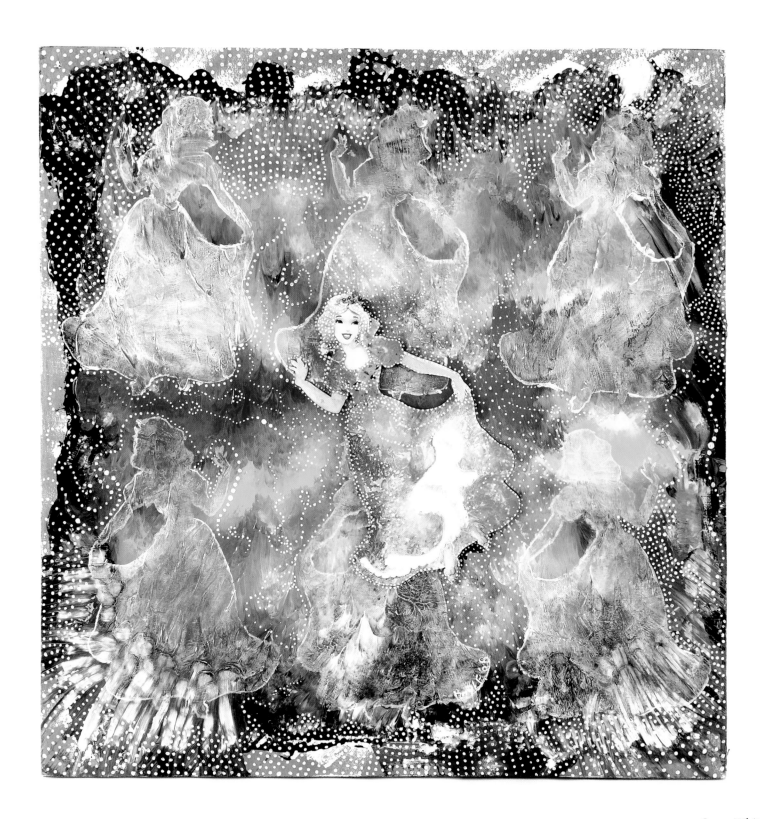

Snow White
Mike Boyle
Acrylic on wood

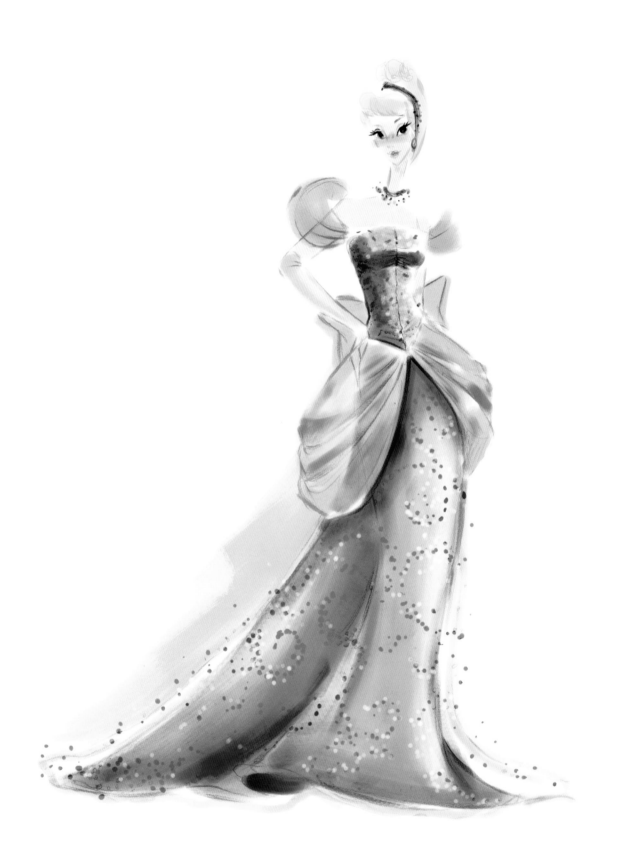

Cinderella
82
Jenny Chung
Digital media

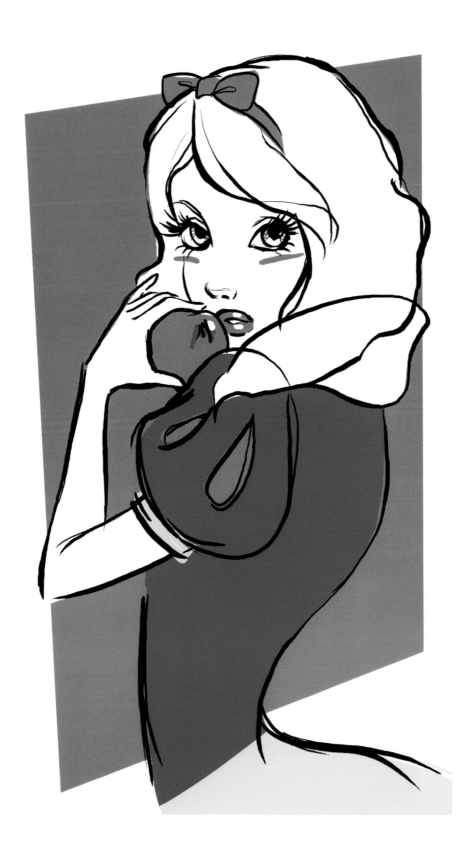

Snow White
Jenny Chung
Digital media

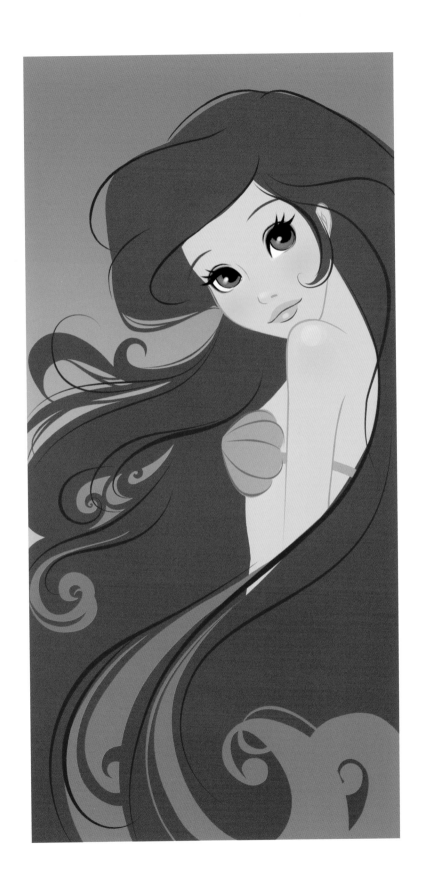

Ariel
84 Jenny Chung
Digital media

In my illustrations, I wanted to focus on the iconic features of my favorite Disney Princesses in simple yet dramatic styles. All the pieces show different elements of art that inspire me—delicate lines, contrast of colors, emphasis on eyes, and cute, fashionable figures. They were all done digitally. The Ariel illustration is the one closest to my heart because she has been my favorite Disney Princess since I was a little girl. In this piece, I wanted to emphasize her beautiful red hair and express her unspoken emotion through her eyes. I decided to add some mystery to the piece by hiding her lower body under her hair so the viewers can decide for themselves whether she is a human or a mermaid.

Jenny Chung

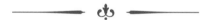

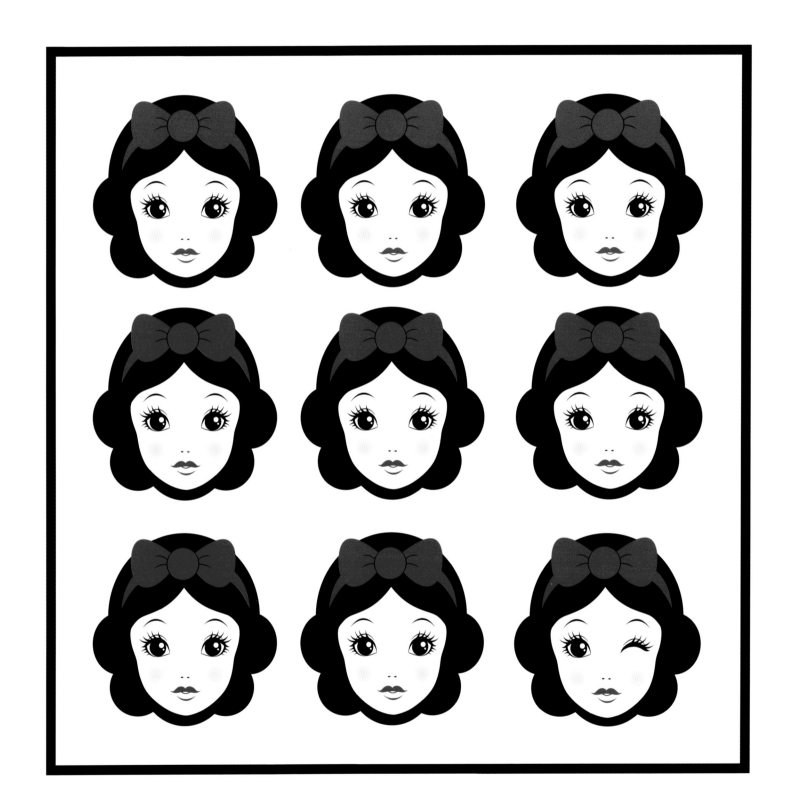

Snow White
Jenny Chung
Digital media

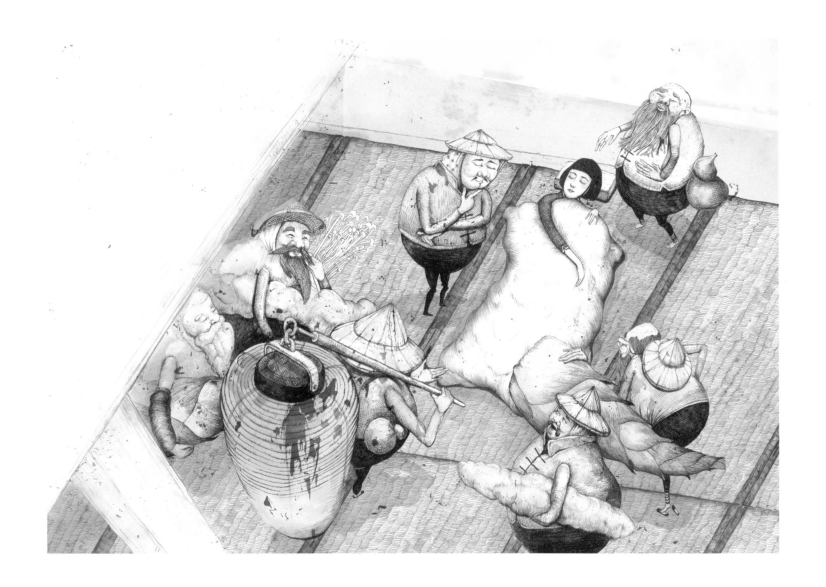

Snow White
Page Tsou
Pen, ink, and digital media

Ariel
John T. Quinn
Pen and ink

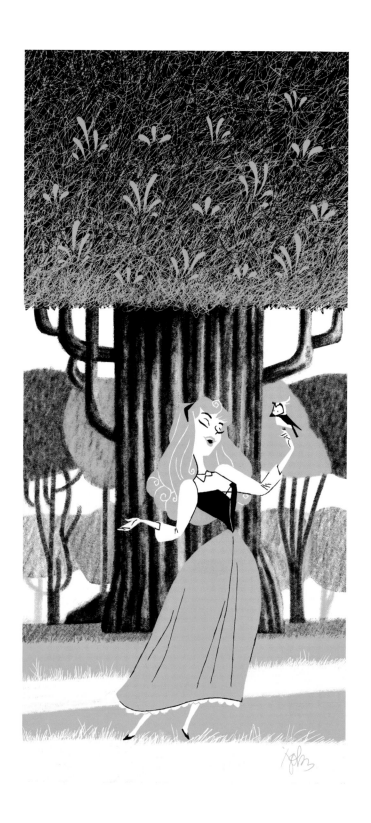

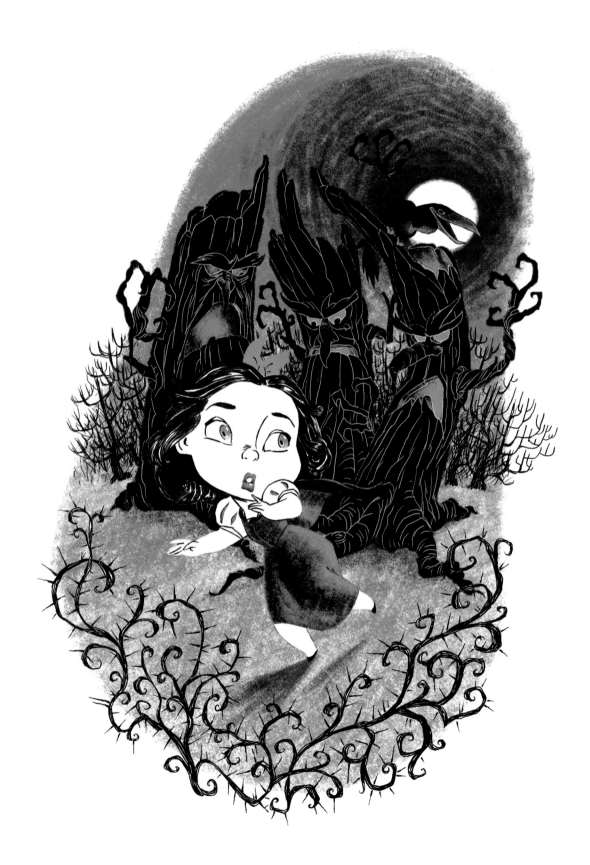

Snow White
John T. Quinn
Digital media

It was the line. It has had me entranced from my earliest memory. I was four or maybe five years old. Seated in a cinema in Sayreville, New Jersey, watching *The Aristocats*. Seeing that frenetic tangle of line dancing across the screen in a hypnotic choreography of character and story—that was the moment I knew I was hooked. Animated cartoons on television were plentiful, and I never missed an opportunity to see them. But for me, the drawings never had the same power as Disney's did. I wanted more. Needed more. I sought out all I could find, even the mushy, romantic girlie stuff. A Princess flees in terror, scrambling through a forest. I'm on the edge of my seat, my popcorn forgotten. A Prince battles a dragon and slashes a path through a dense thicket of thorny bramble to awaken a sleeping Princess. Don't tell my brothers, but I loved every second of it! The drawings moved, the drawings thought, the drawings emitted a siren's song. I could hear them calling to me from Southern California, from a campus in Burbank, from the desks of nine old alchemists who made life from line. I have always wanted to be a part of this magic.

John T. Quinn

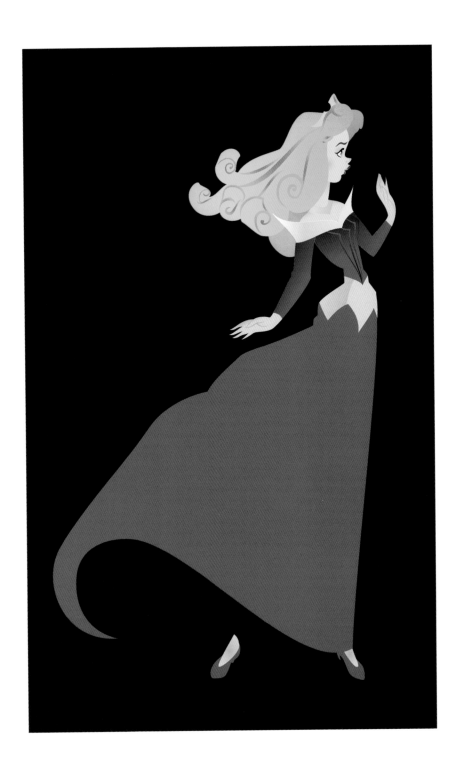

Aurora
92 John T. Quinn
Digital media

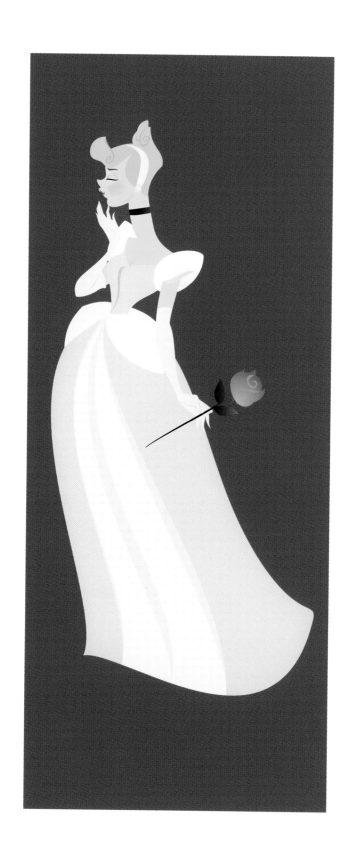

Cinderella
John T. Quinn
Digital media

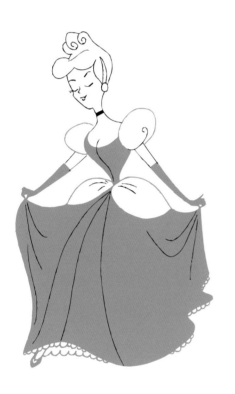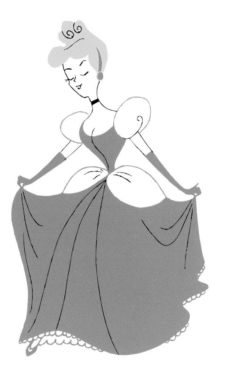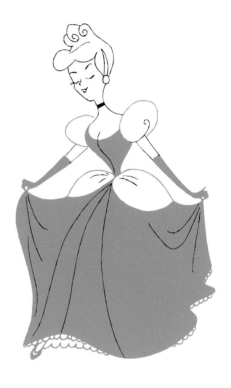

Cinderella
John T. Quinn
Digital media

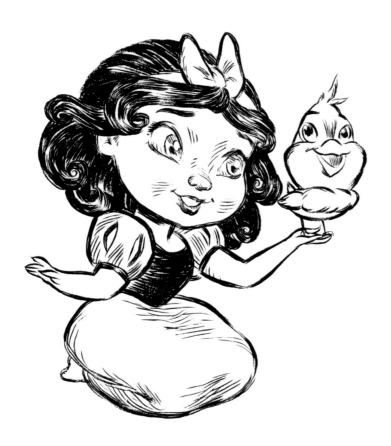

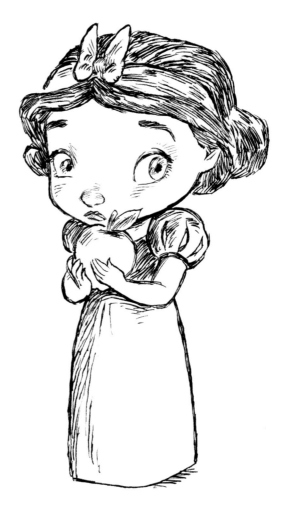

Snow White
John T. Quinn
Pen and ink

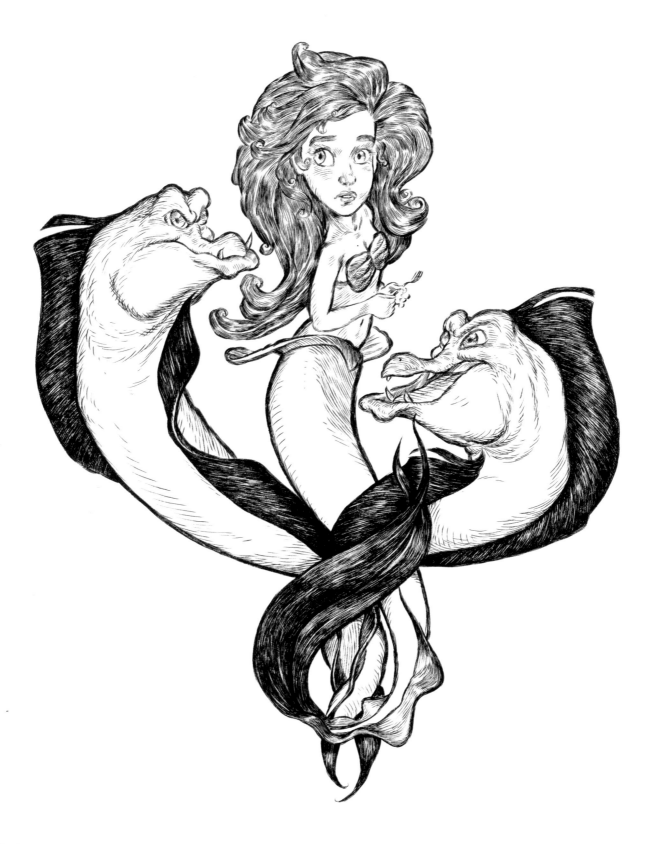

Ariel
John T. Quinn
Pen and ink

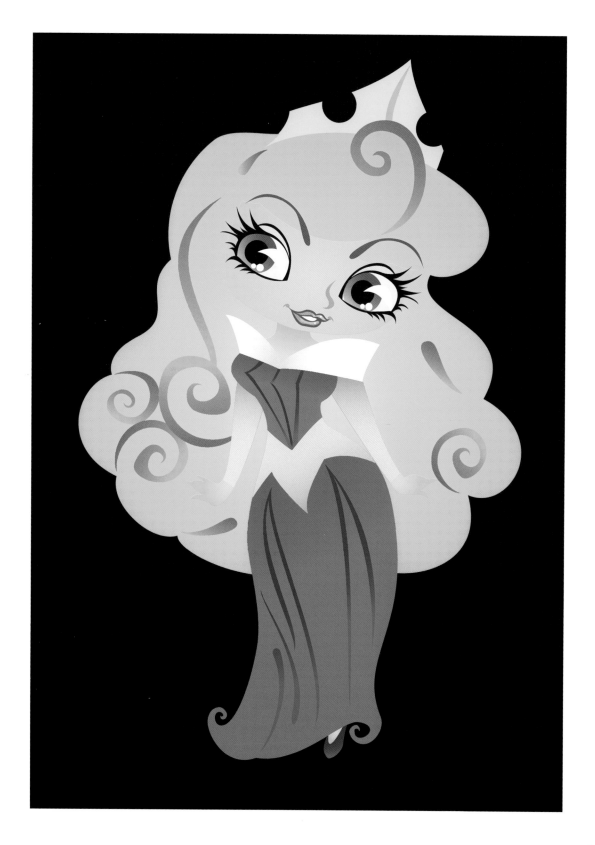

Aurora
John T. Quinn
Digital media

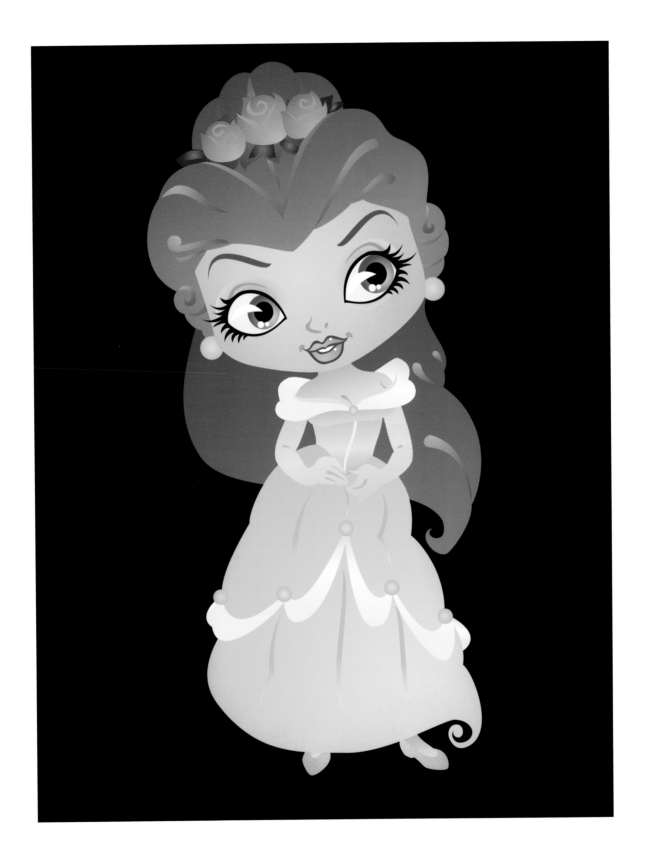

Belle

98

John T. Quinn

Digital media

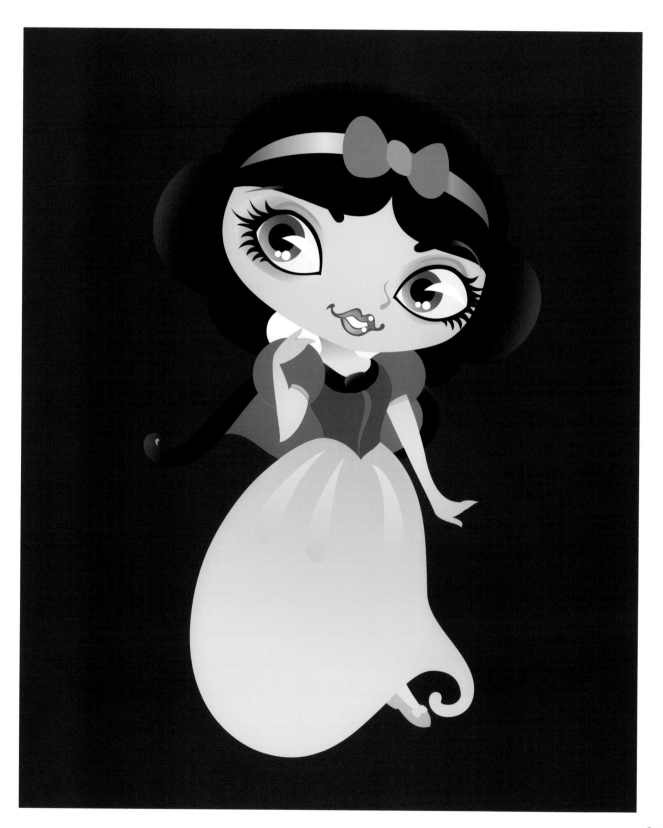

Cinderella
100 Katie Weekes
Digital media

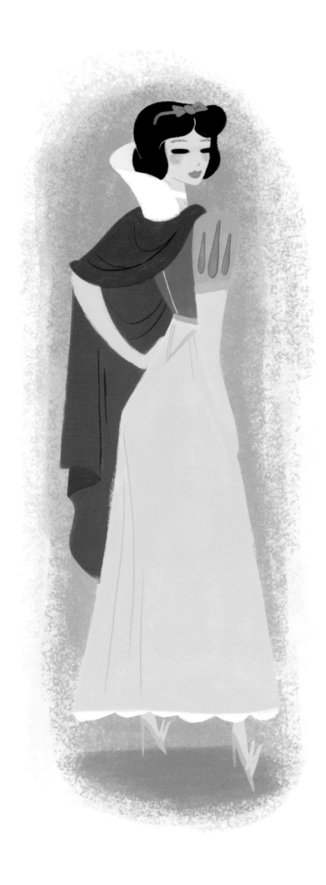

Snow White
Matt Cruickshank
Digital media

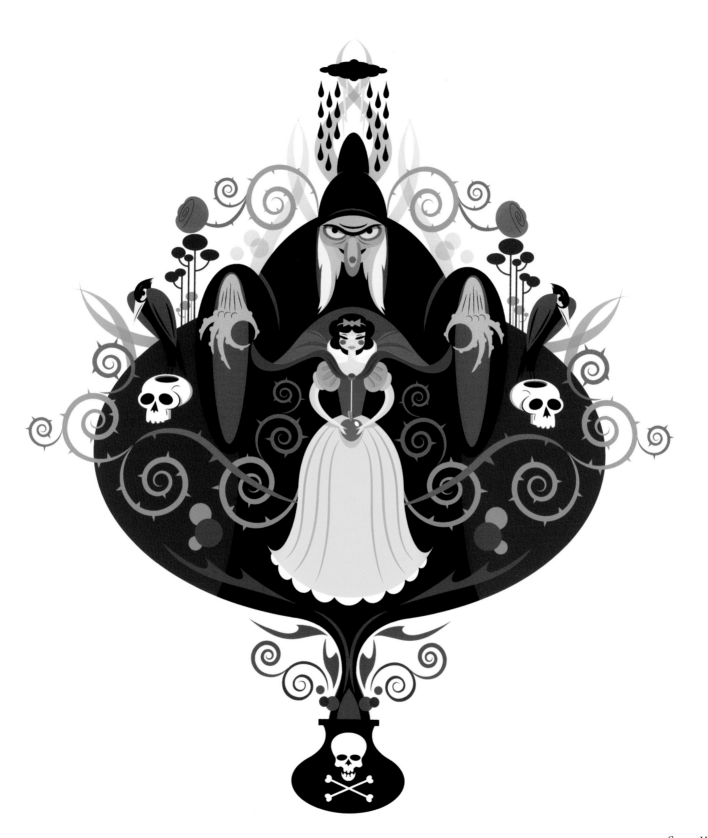

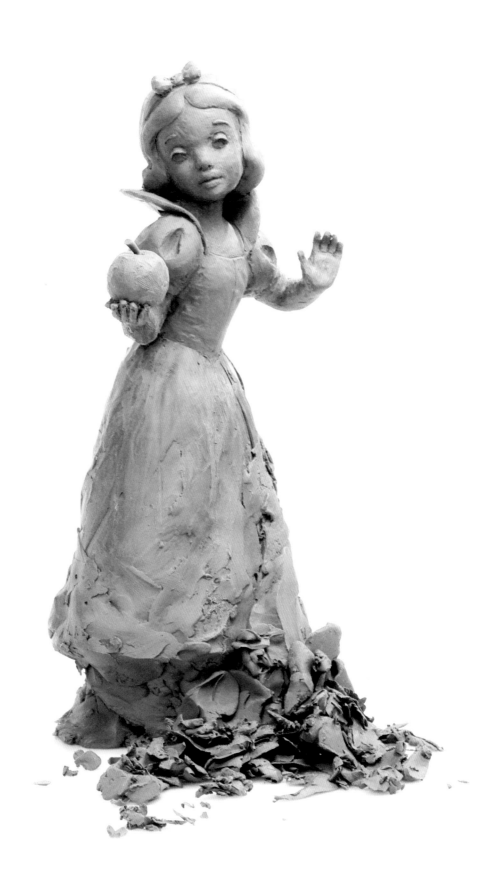

Snow White
104 Margaret Leahy
Clay

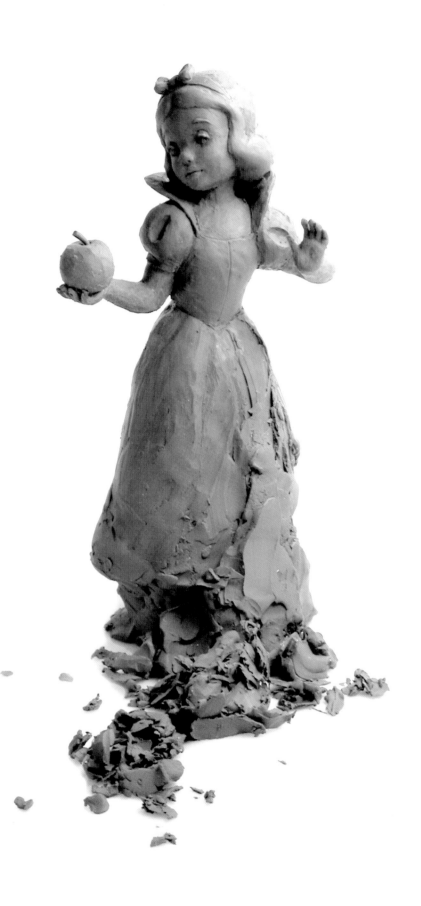

Snow White
Chad Sommers
Pencil and digital media

Snow White has always been my favorite Princess. Her strong connection with nature piqued my imagination. The way the animals followed her around and vied for her attention really impressed me. Who wouldn't love a tiny little bird to randomly land on your finger, look you in the eye, and sing to you? Along with this amiable nature, I also saw a little bit of mystery behind her gaze, a serene yet longing look as she waited for her Prince to come. She seemed content and happy, yet unfulfilled. To create this illustration I found inspiration in the surrealistic art style of Salvador Dalí. I felt that an abstract format like this would really help to bring out Snow White's inner beauty and personality while using surrealism as a bit of an illusion.

Chad Sommers

Jasmine

108Neysa Bové

Digital media

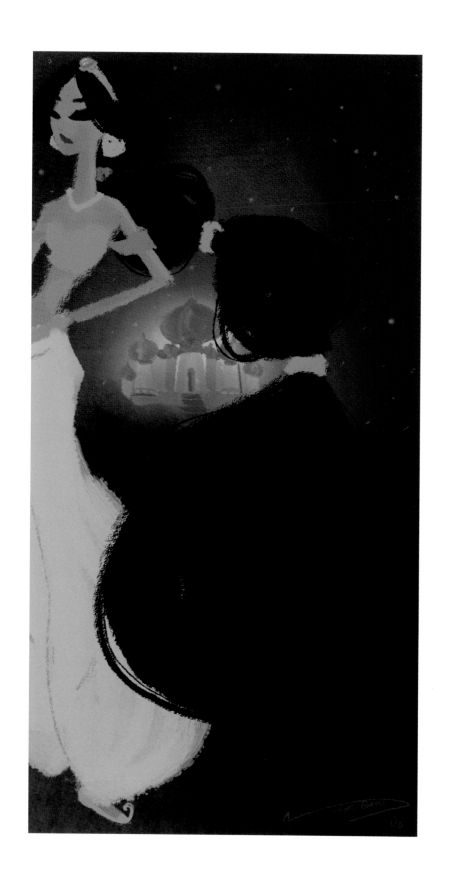

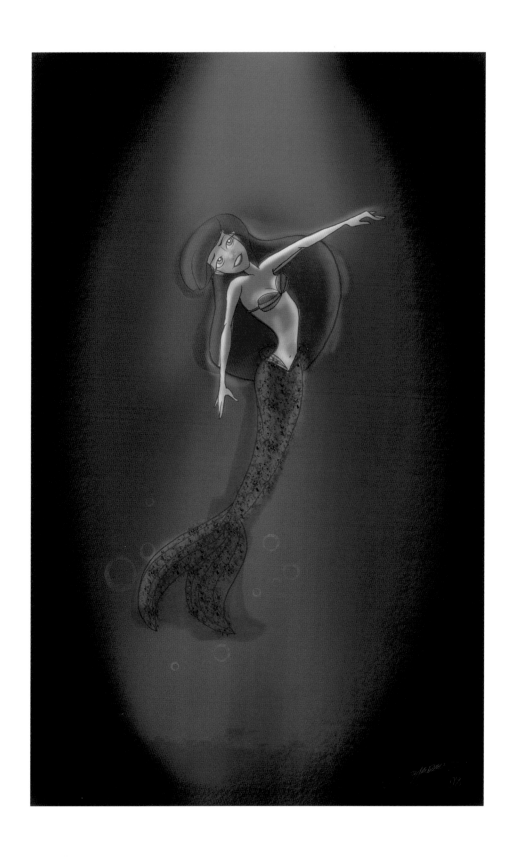

Ariel
110 Neysa Bové
Digital media

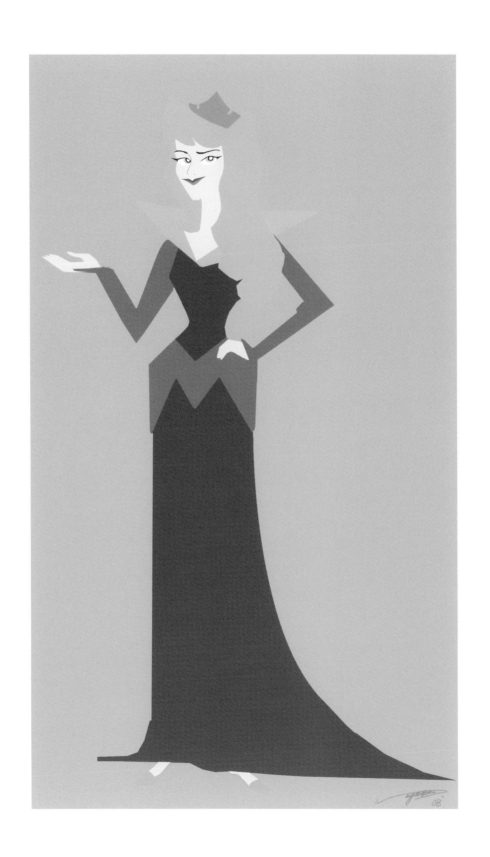

Aurora
Neysa Bové
Digital media

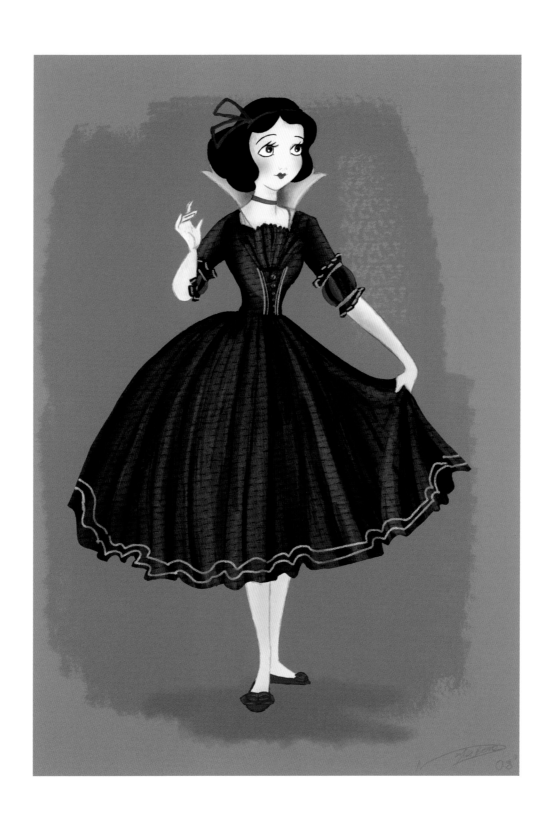

Snow White
112 Neysa Bové
Digital media

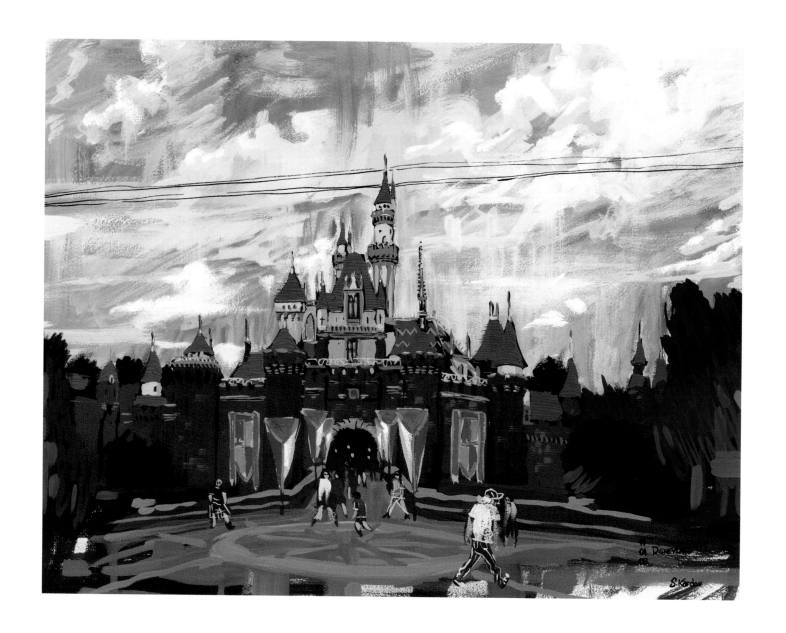

Aurora
Stephane Kardos 113
Gouache

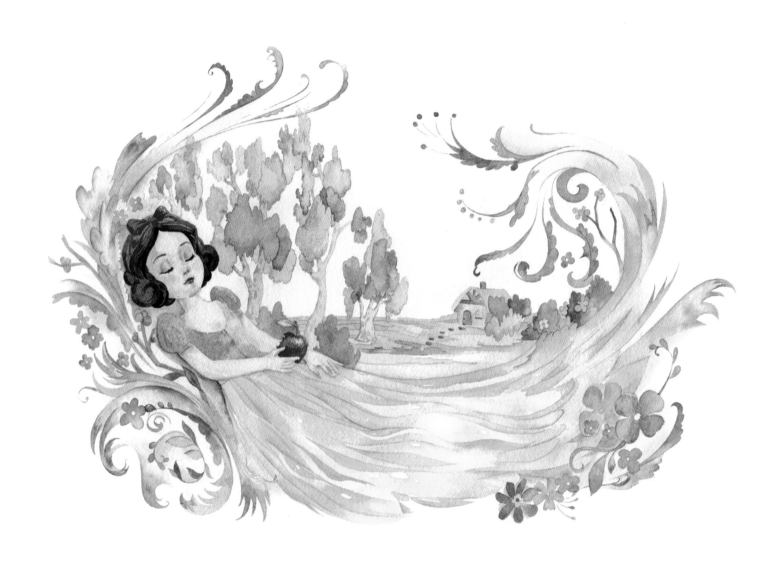

Snow White

Rebecca Wong

Watercolor, gouache, and ink on watercolor paper

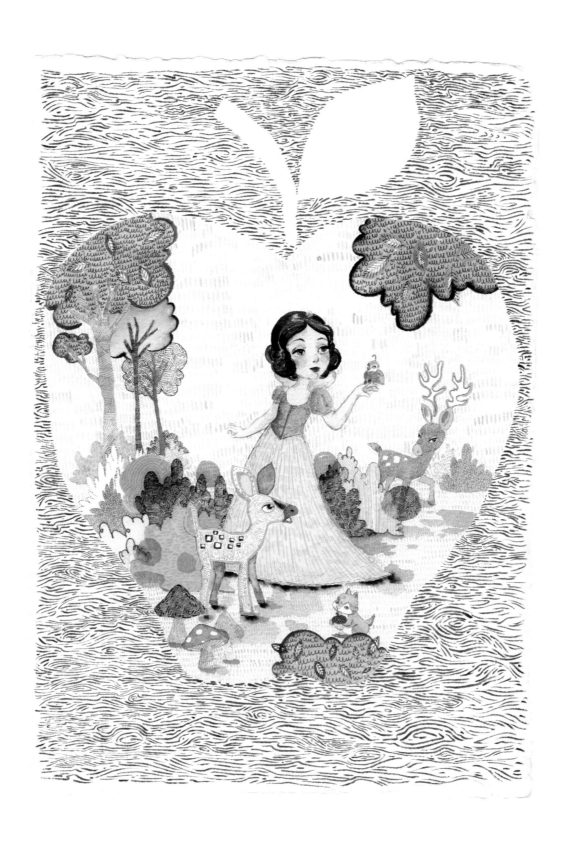

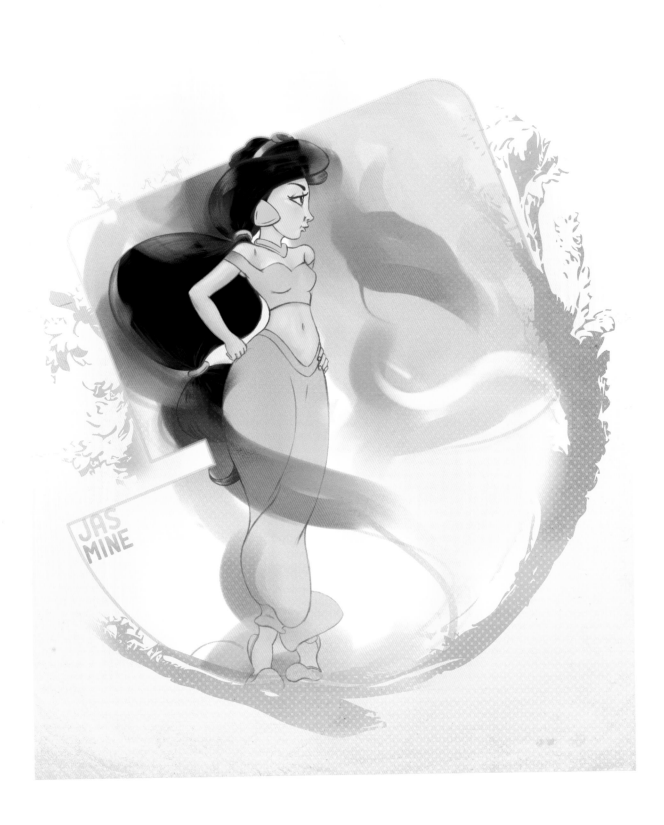

Jasmine
116
Oskar Mendez
Pencil on paper and digital media

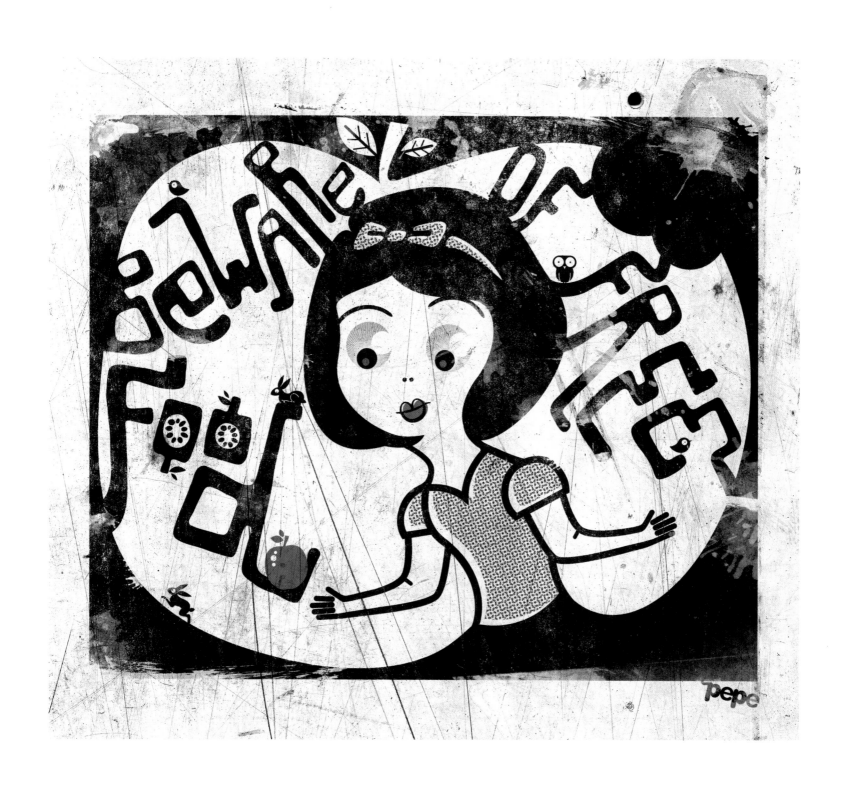

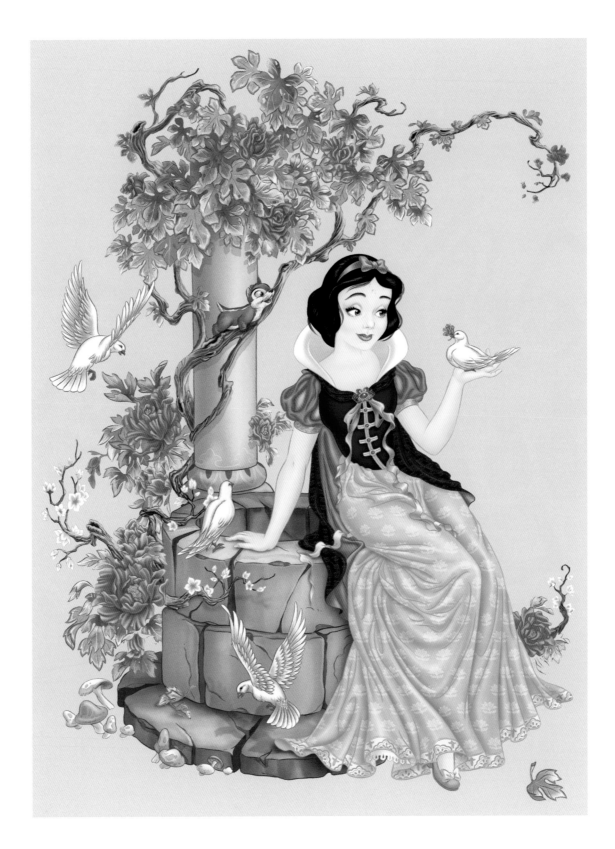

Snow White

118 Pedro Astudillo

Pencil on marker paper and digital media

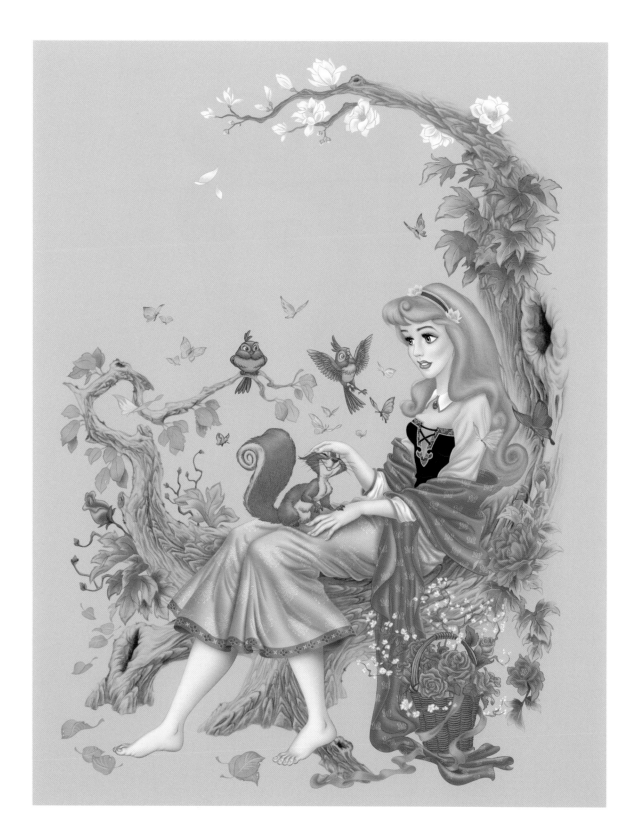

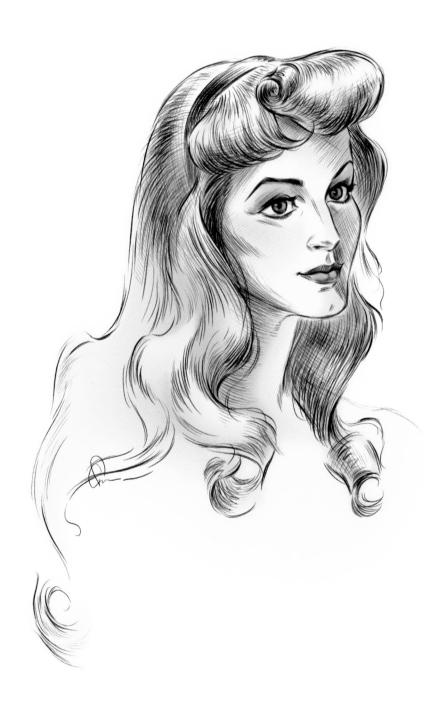

Aurora

Pedro Astudillo

Pencil on watercolor paper

This is actually someone I've known for years, whose beauty has always reminded me of Aurora's (my favorite Disney Princess). So, after I told her what I wanted to do, she graciously agreed to pose for me for almost an hour. With the exception of the hair (her hair is blond, but straight instead of wavy), I didn't add or take away any features in order to achieve a closer resemblance to Princess Aurora. My gratitude goes to her for granting me a few minutes of her busy life as a new mom. This piece is also my humble homage to Charles Dana Gibson, a true American master.

Pedro Astudillo

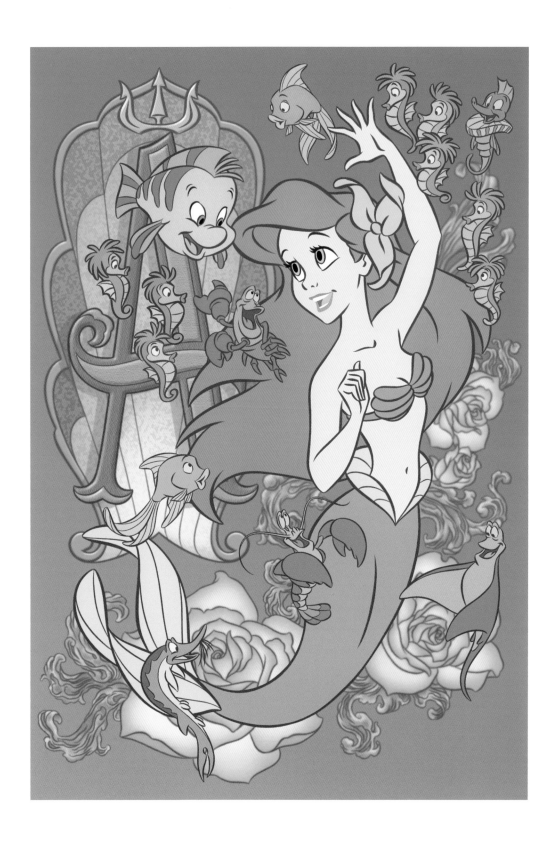

Ariel

Pedro Astudillo

Pencil on marker paper and digital media

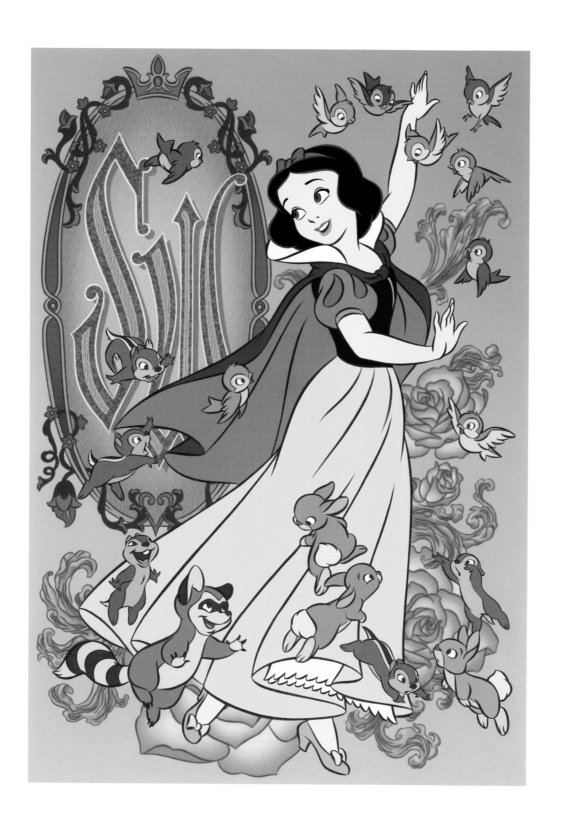

Snow White
Pedro Astudillo
Pencil on marker paper and digital media

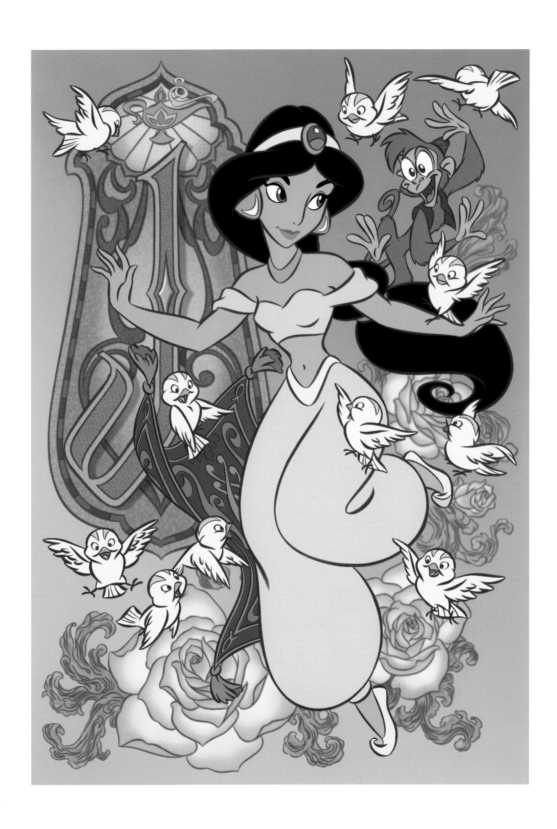

Jasmine

Pedro Astudillo

Pencil on marker paper and digital media

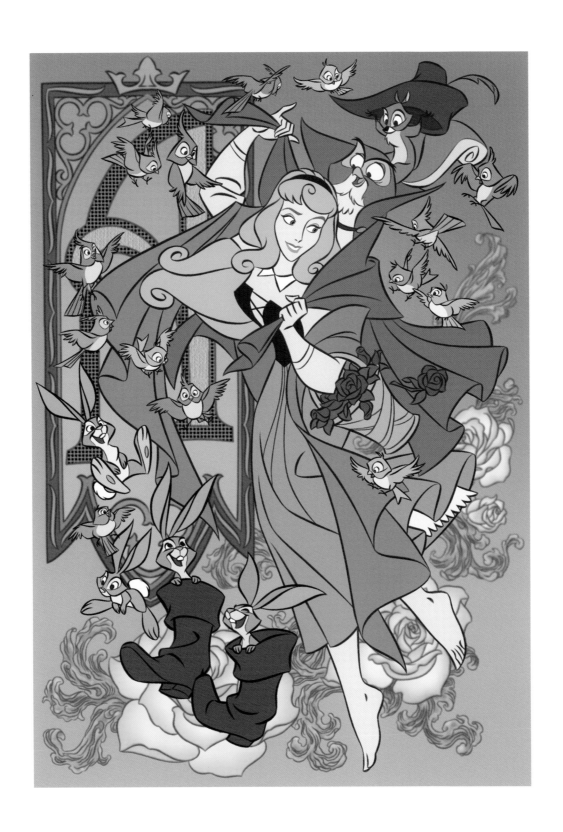

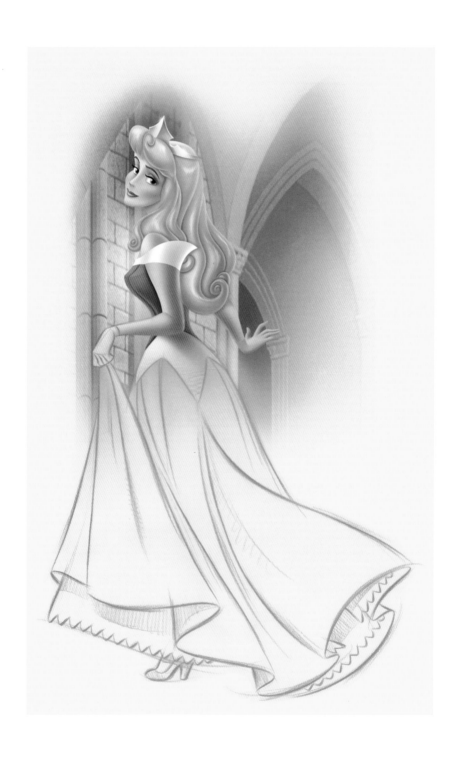

Aurora

Pedro Astudillo

Pencil on marker paper and digital media

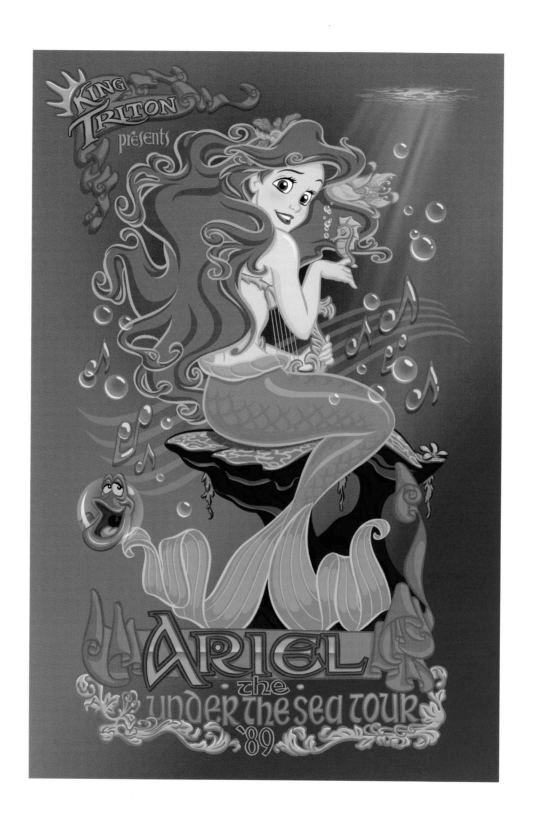

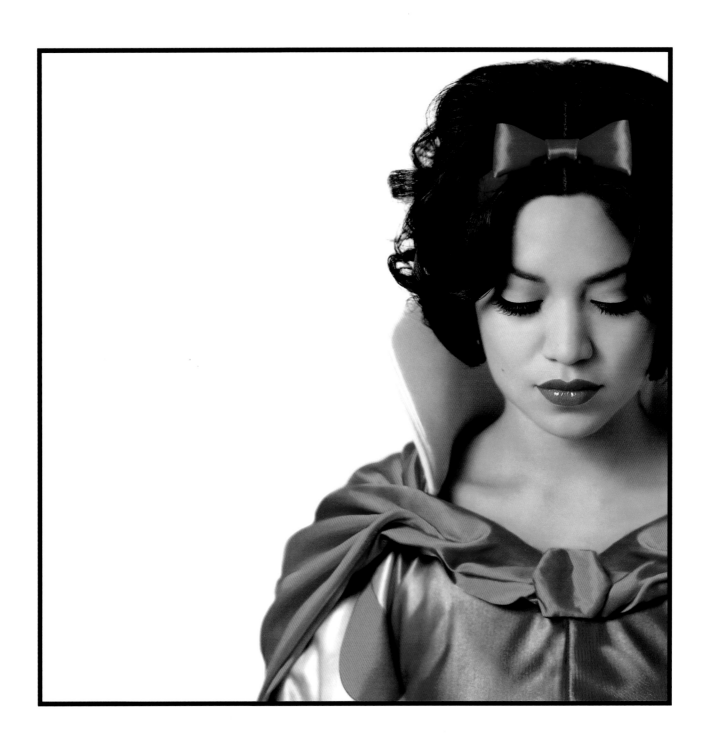

Snow White
128 Ryan Astamendi
Photography and digital media

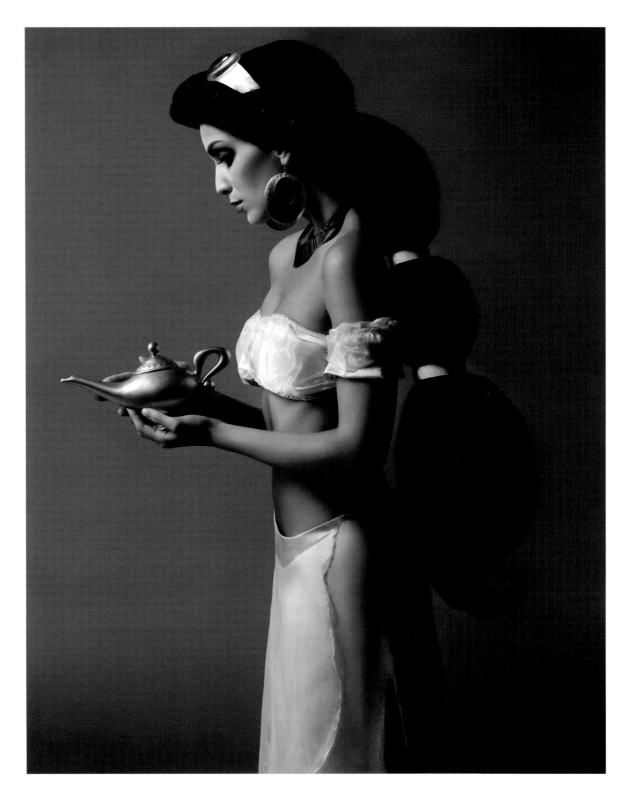

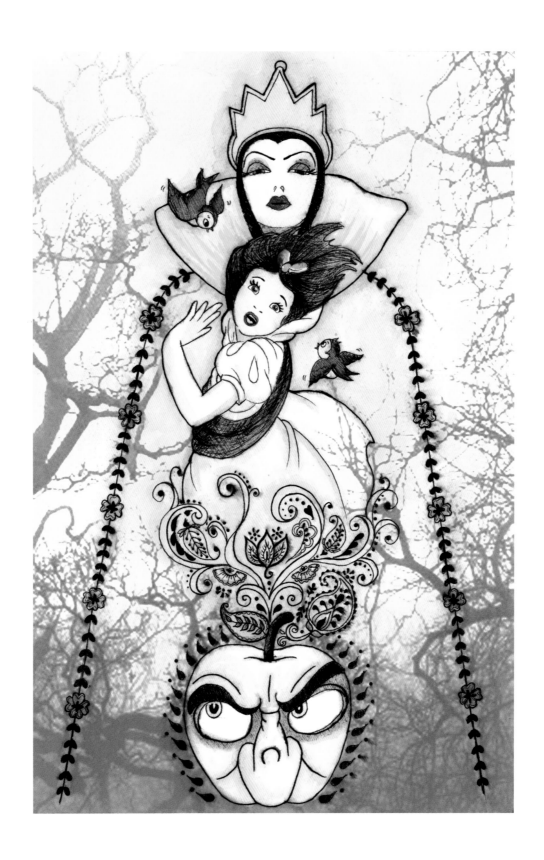

Snow White
Regina Alphonso
Pen, watercolor, and digital media

Cinderella
Rich Tuzon
Mixed media

131

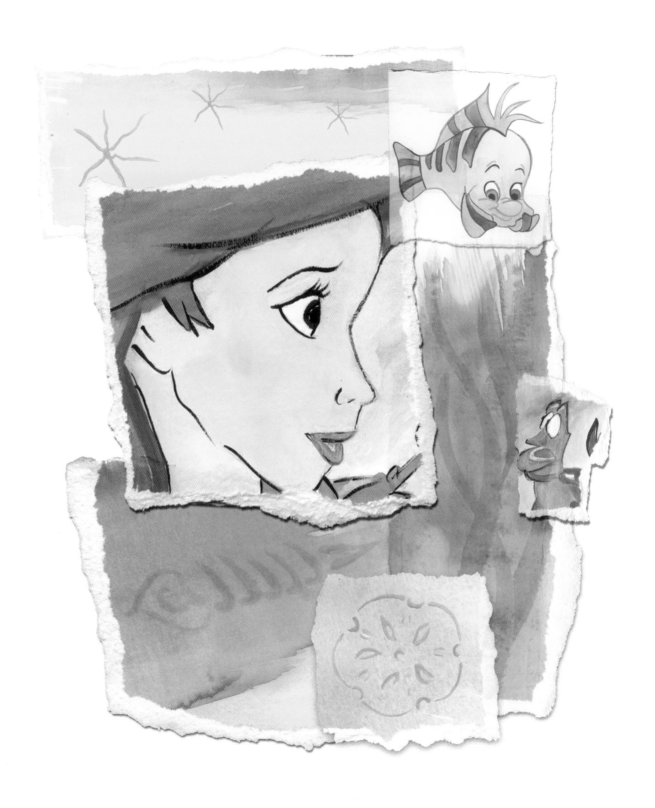

Ariel
Stephanie Shapiro
Watercolor

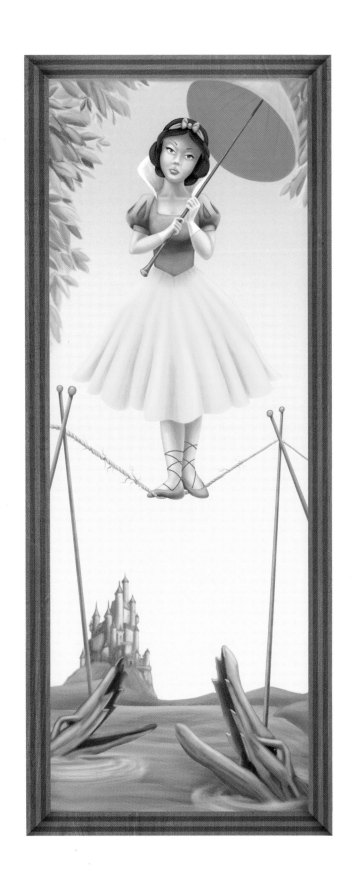

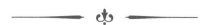

I chose to paint Belle because of her wit and intelligence. In looking for a style, I remembered Francois Boucher's *Portrait of Madame Pompadour*, painted in oils around 1750. Madame Pompadour was the favorite of King Louis XV, and Monsieur Boucher was the royal painter. I imagined what it would have been like if Boucher had been able to paint our Princess Belle, and the rest is as you see!

Maria Elena Naggi

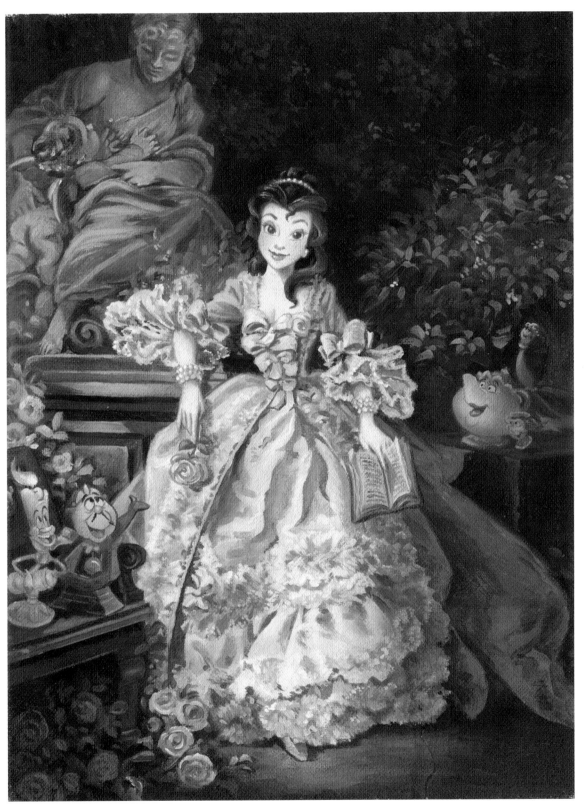

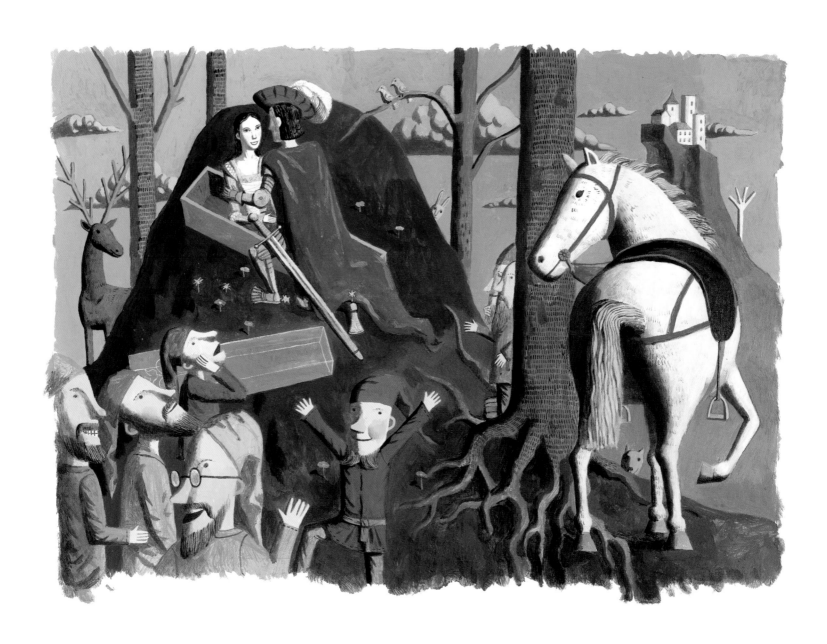

Snow White

Artem Kostyukevich

Acrylic

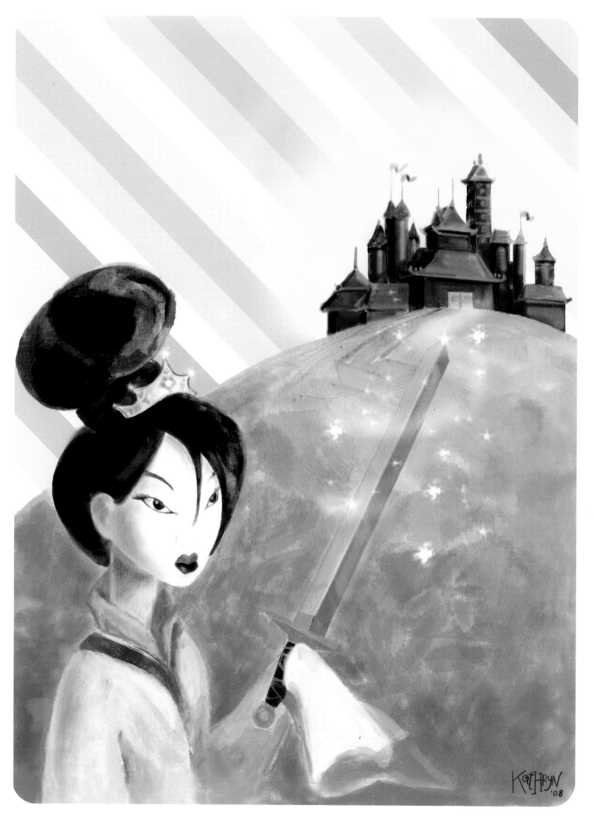

Mulan
Kathryn Kulish
Acrylic and digital media

Choose your dress

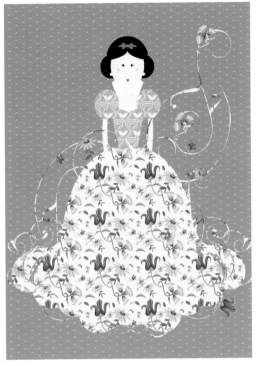

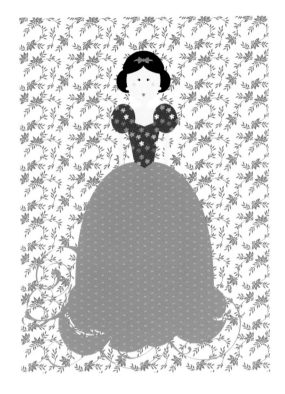

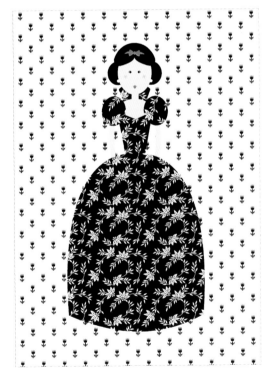

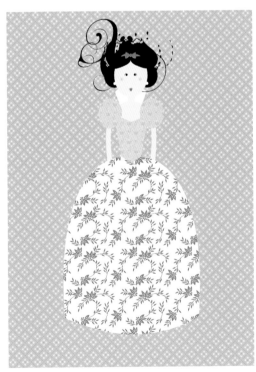

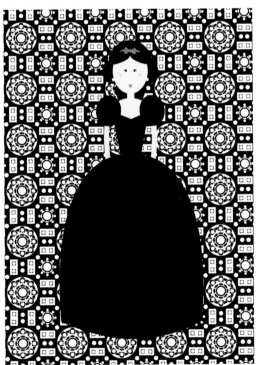

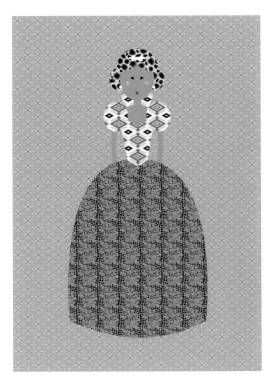

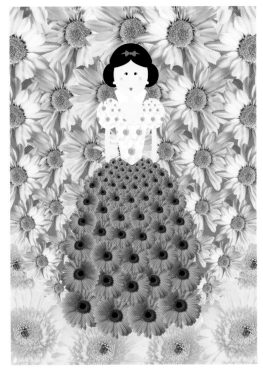

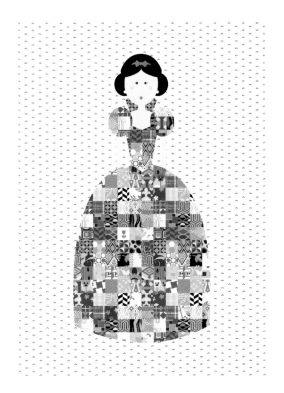

Snow White
Paulo Tripitelli
Digital media

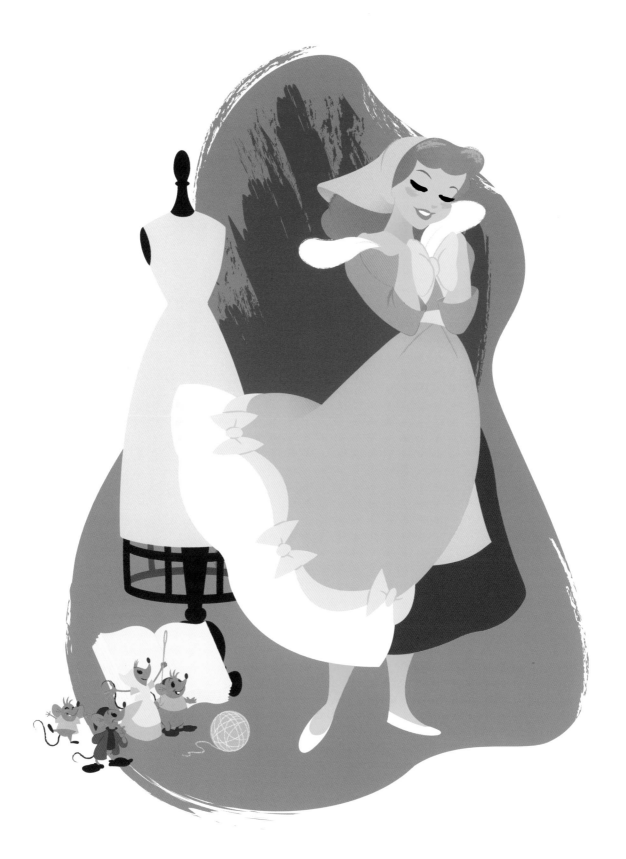

Cinderella
140 Steve Thompson
Digital media

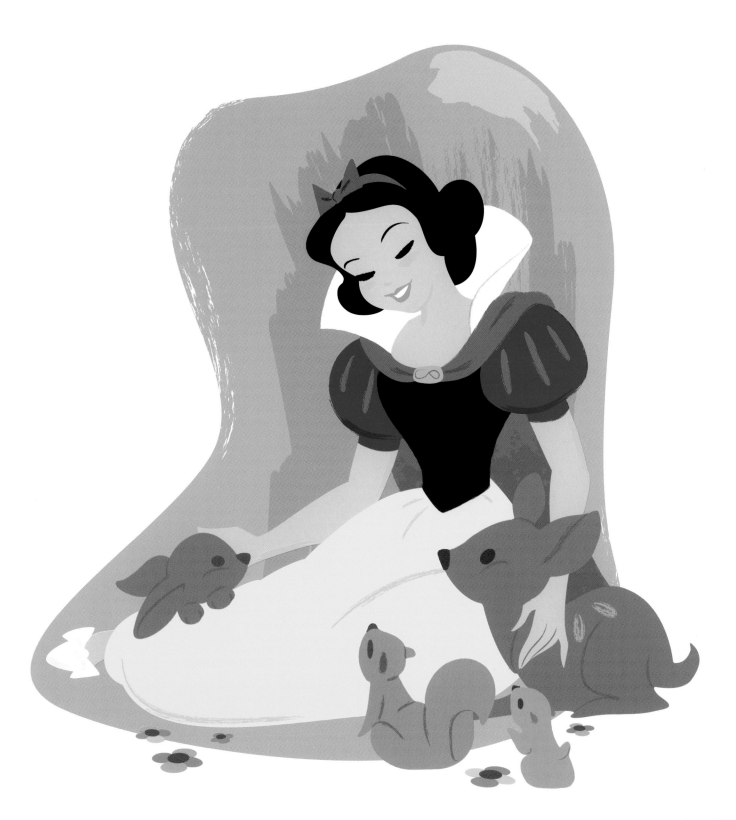

Snow White
Steve Thompson
Digital media

141

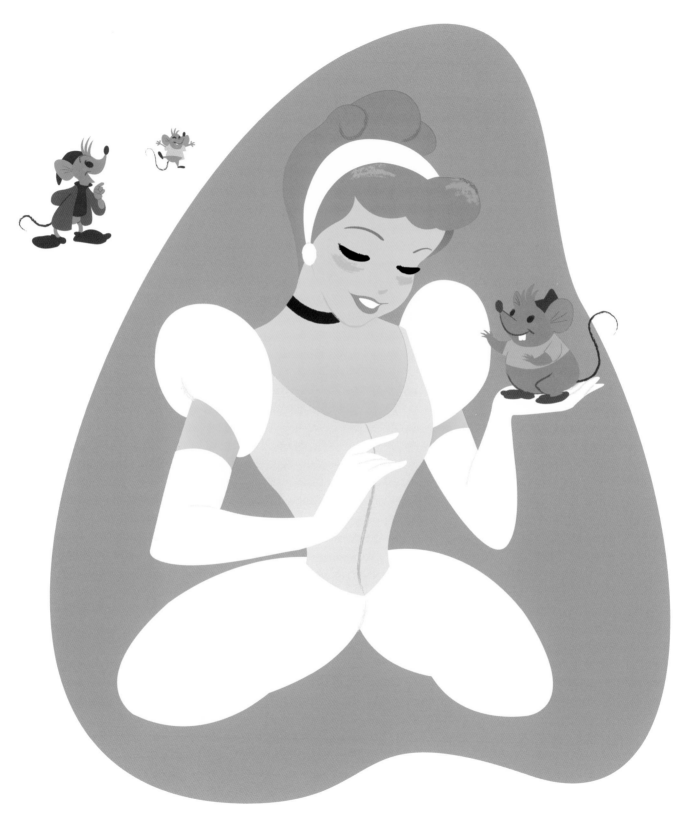

Cinderella
Steve Thompson
Digital media

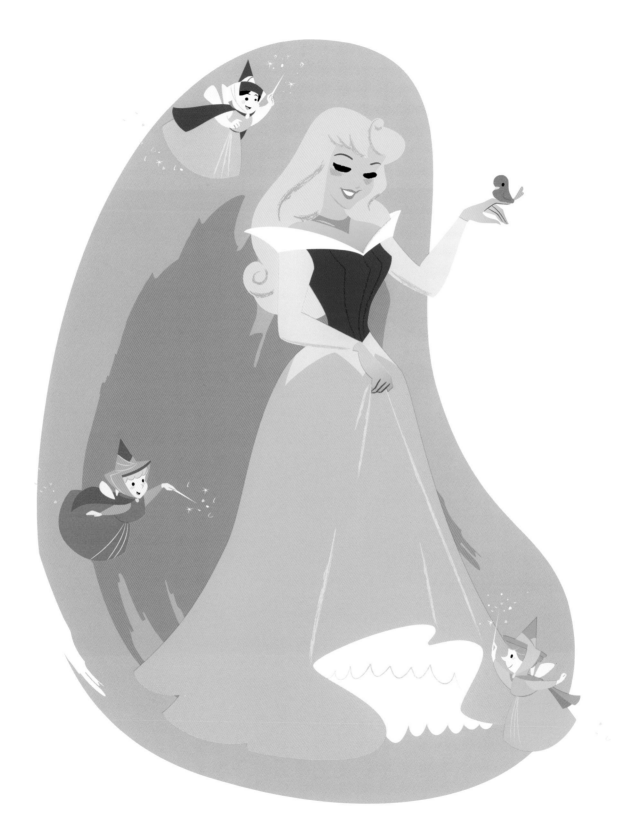

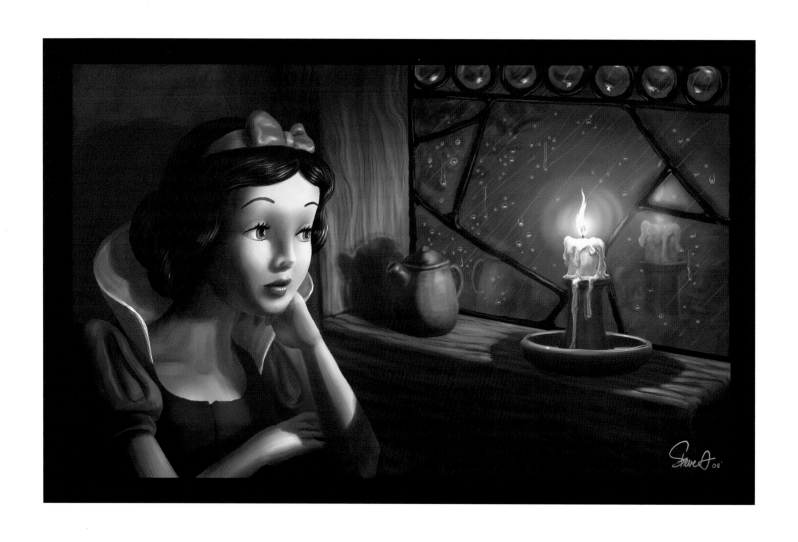

Snow White

144 Steve Andrews

Digital media

Belle
Ray Leoncio
Digital media

A moment of clarity—or just a few seconds of quiet delusion caused by the stress of witches and magic spells? Judge for yourself. I wanted to think of how these young women would react to the strange circumstances surrounding them. And to show a feisty, determined side to them—independent of a prince or other type of suitor who could sweep in and save the day. I fashioned these panels after the old comic-book romance stories created by guys like Joe Simon and Jack Kirby, and later popularized further in the syndicated comic strips *The Heart of Juliet Jones* and *Mary Perkins, On Stage*. Most heroine-driven strip and comic-book characters have a deep affinity for introspection, so we have a chance to get inside their heads. I like to think that these thoughts came to the Princesses' minds as they fought their way through their challenging destinies. Many of the female characters featured in comic strips had to be survivors—there was always next week, next year. That's the type of empowerment I tried to instill in the characters.

Vince Musacchia

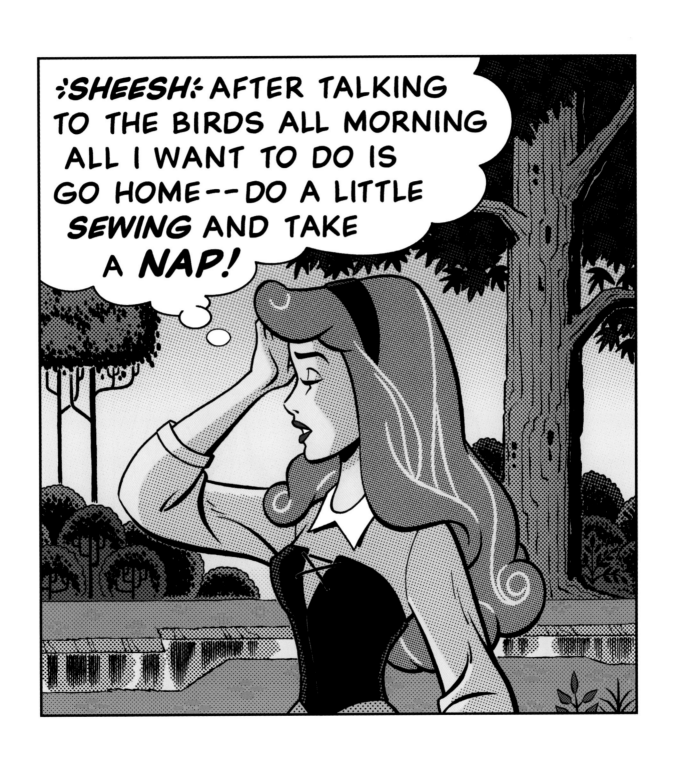

Aurora
Vince Musacchia
Pencil, ink, and digital media

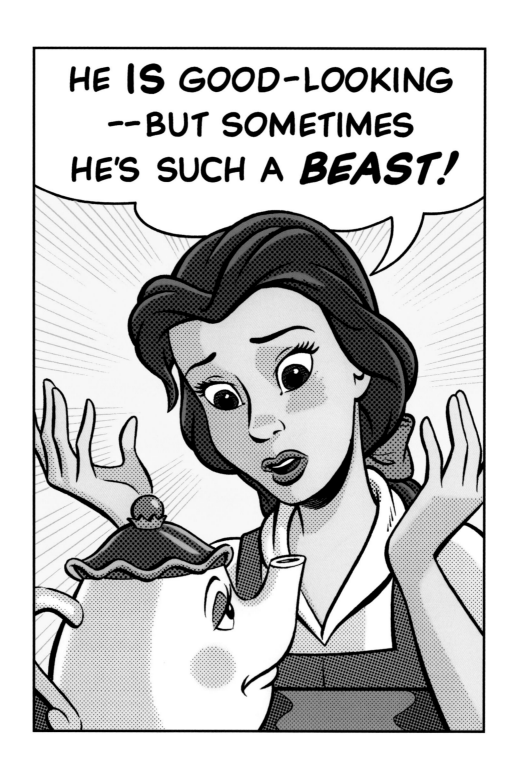

Belle
Vince Musacchia
Pencil, ink, and digital media

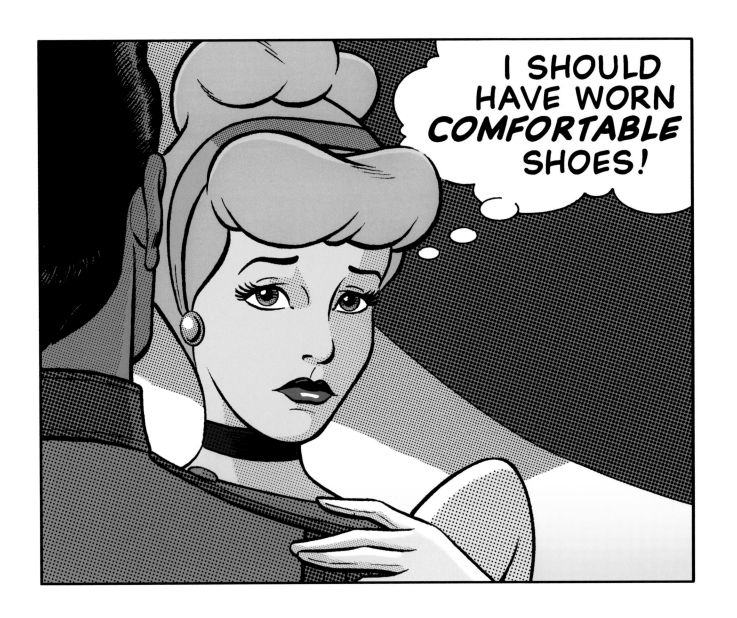

Cinderella
Vince Musacchia
Pencil, ink, and digital media

Snow White
Timothy Palin

Digital media

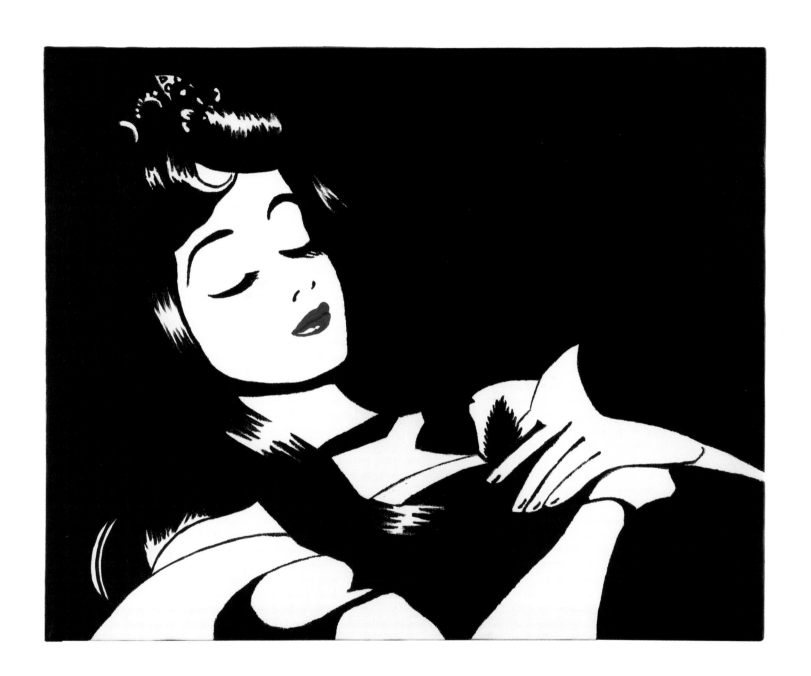

Aurora
Diana Tran 151
Acrylic on canvas

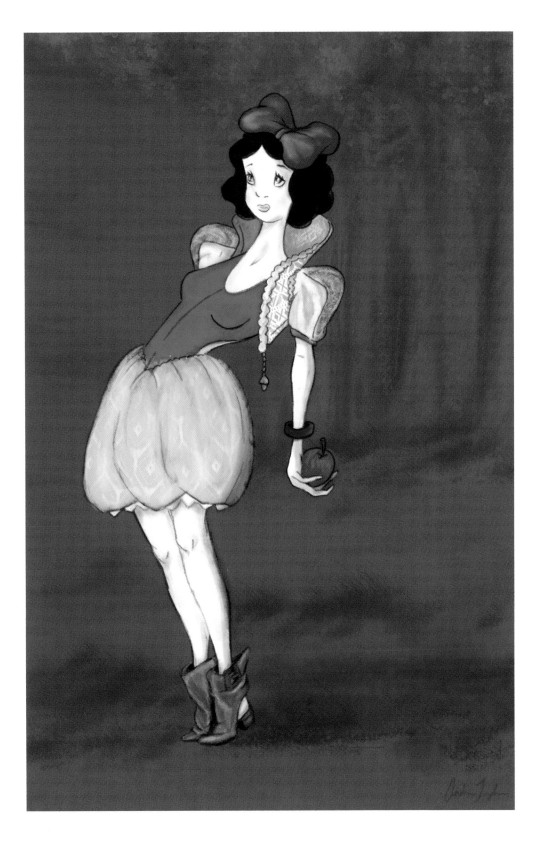

Snow White
Andrew Taylor

Pencil and digital media

Aurora

Courtney Watkinson

Watercolor and colored pencil

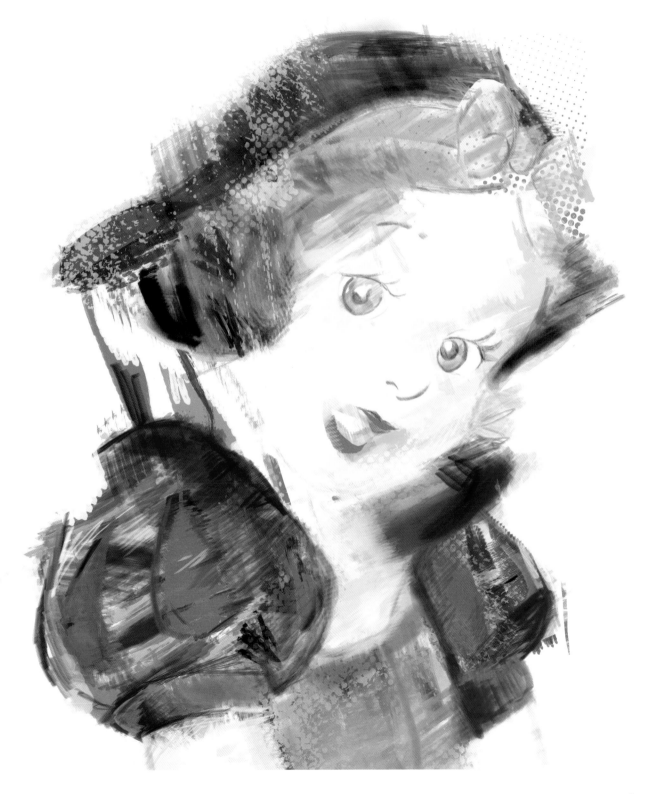

Snow White
Rebecca Cronin
Digital media

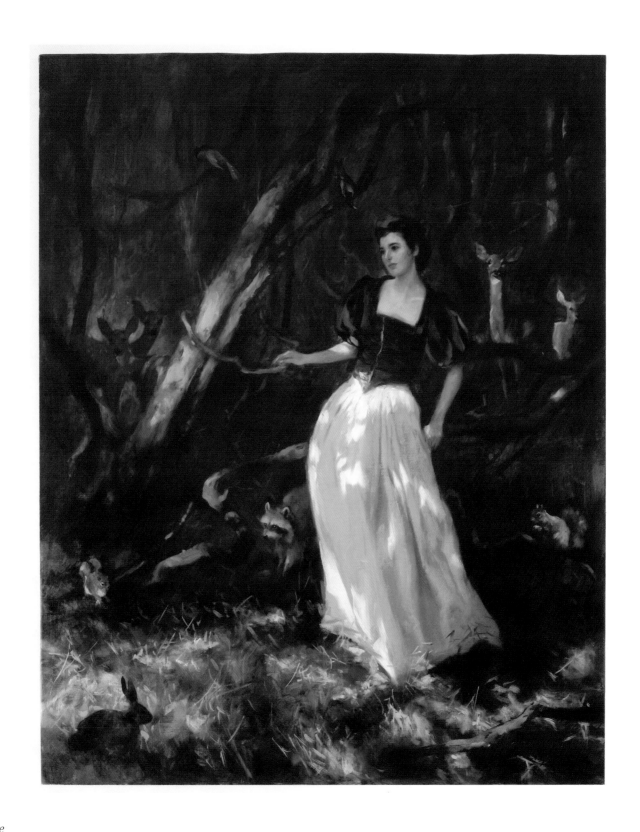

Snow White
156 Glenn Harrington
Oil on linen

Pocahontas
Charles Binford
Digital media

Belle
158 Robert Heath
Digital media

Pocahontas

160 Zoro Rodriguez

Pencil and digital media

I chose Pocahontas because her hair has a personality of its own, which fits perfectly with what I had in mind for this piece. Pocahontas also went against the norms of her culture, just like a graffiti artist goes against his. This is a mixed media work consisting of a pencil drawing and a scanned background that were manipulated digitally. I was influenced by the graffiti art in Los Angeles. Growing up here as an artist, it's hard not be influenced by graffiti when it's all around you.

Zoro Rodriguez

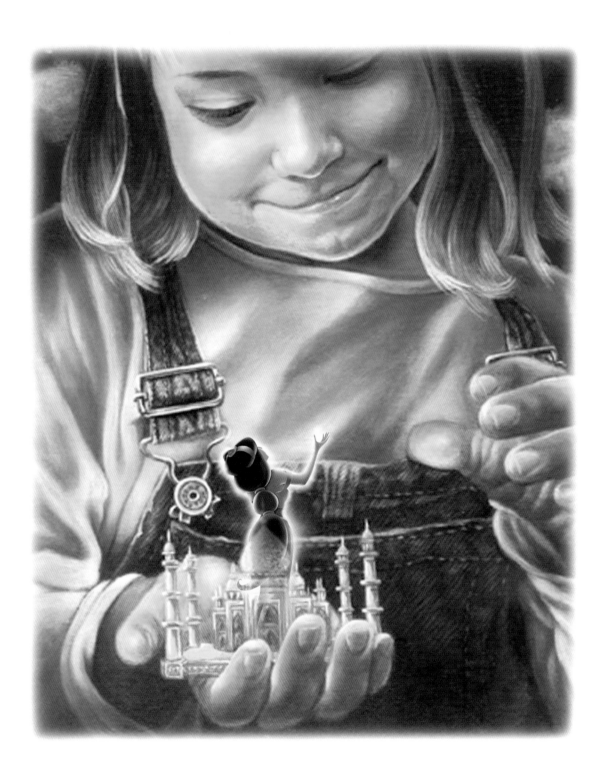

Jasmine

162 John Trinh

Acrylic and digital media

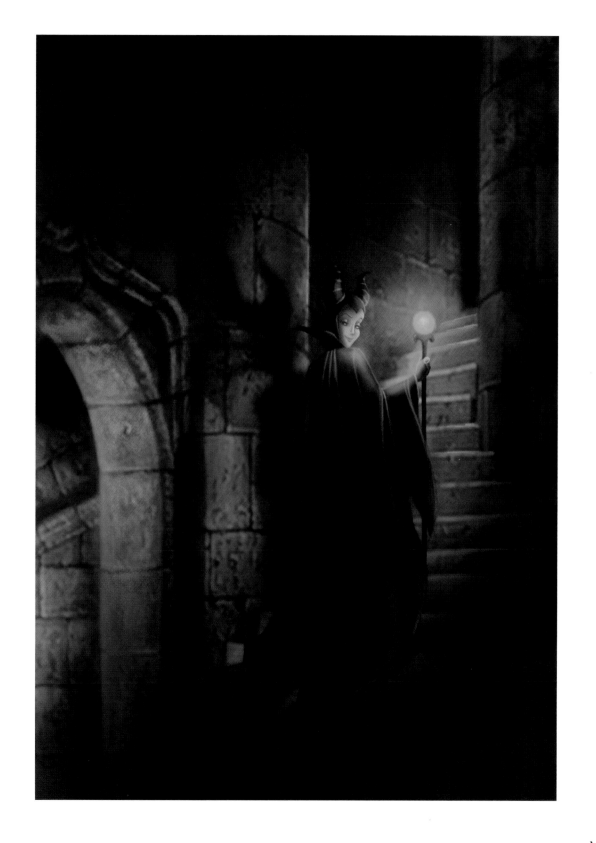

Aurora
Marco Colletti
Digital media

Aurora
Mike Levasheff
Photography

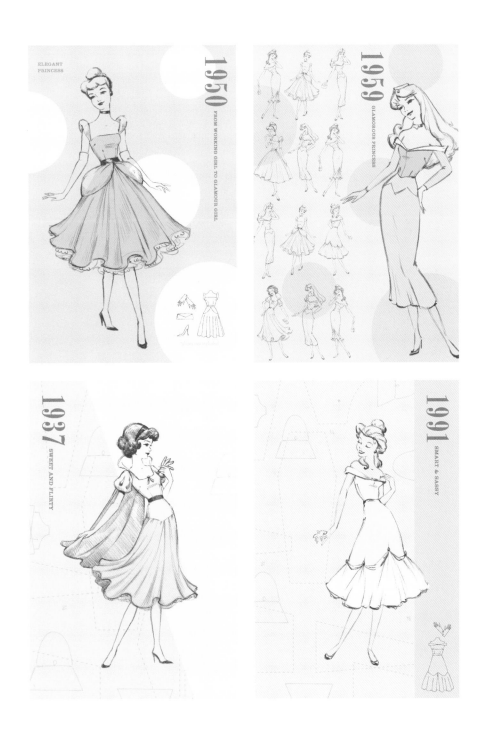

ELEGANT
PRINCESS

1950
FROM WORKING GIRL TO GLAMOUR GIRL

1959
GLAMOROUS PRINCESS

1937
SWEET AND FLIRTY

1991
SMART & SASSY

Princesses
Kim Sage and Becky Wong
Pencil and digital media

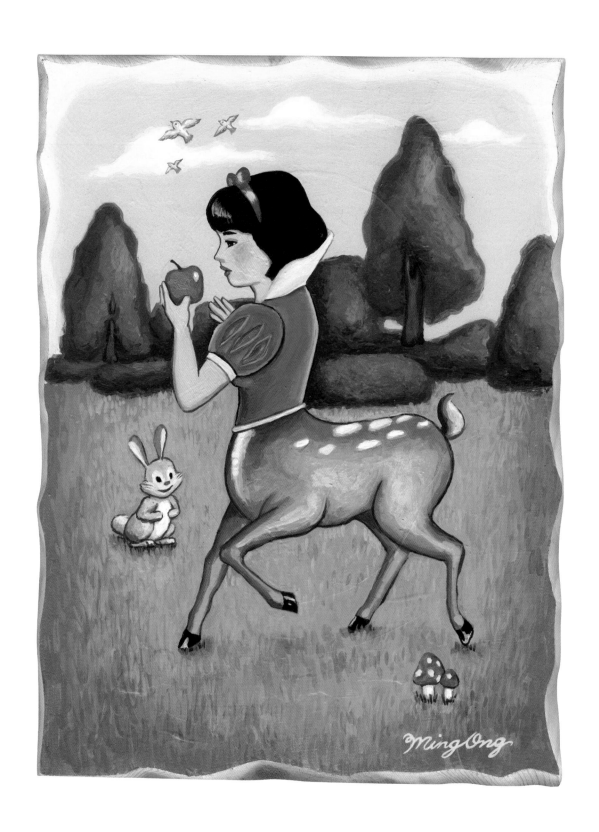

Snow White
Ming Ong
Acrylic on wood

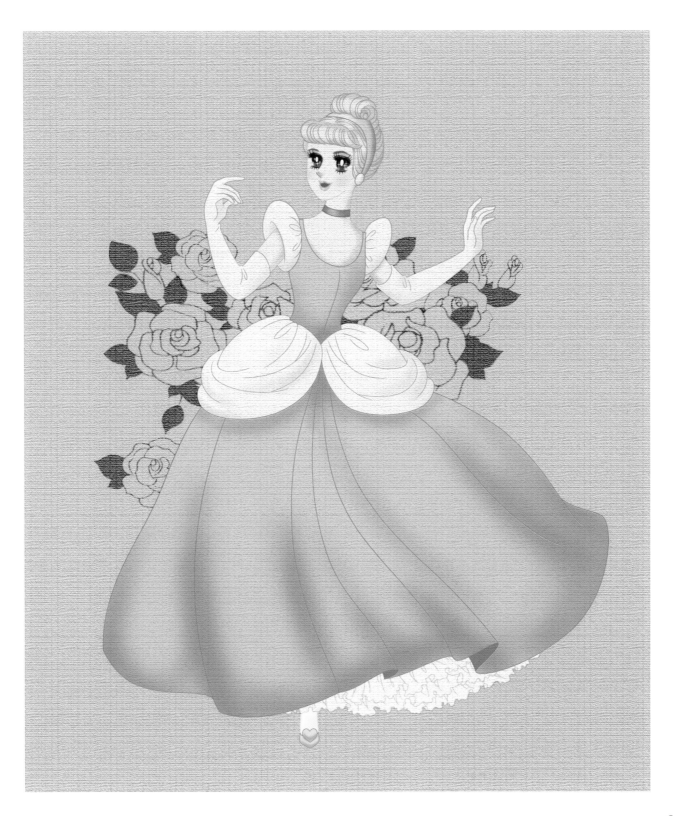

Cinderella
Mi Ran Kim 167
Pencil and digital media

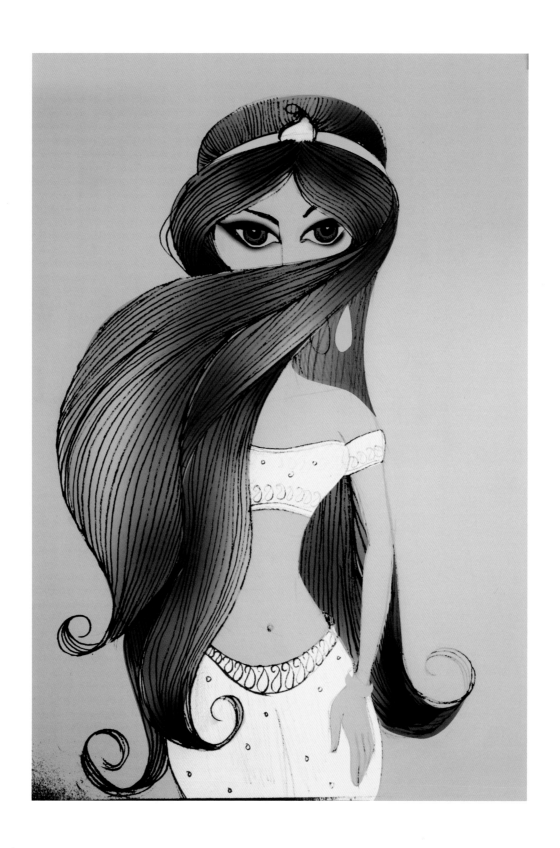

Jasmine
Maulshree Somani

Pencil and pen on paper and digital media

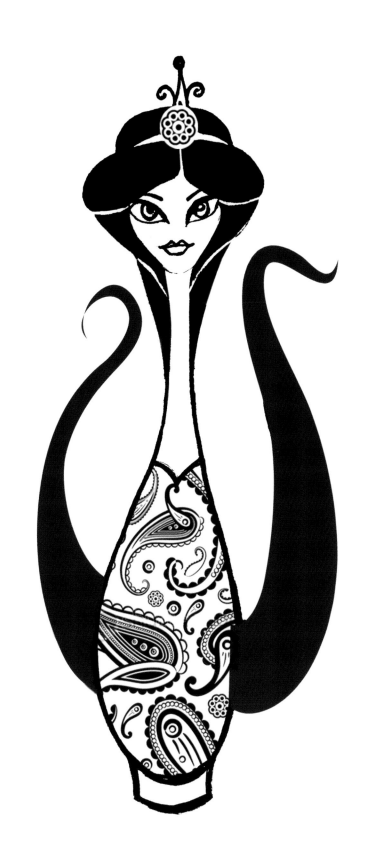

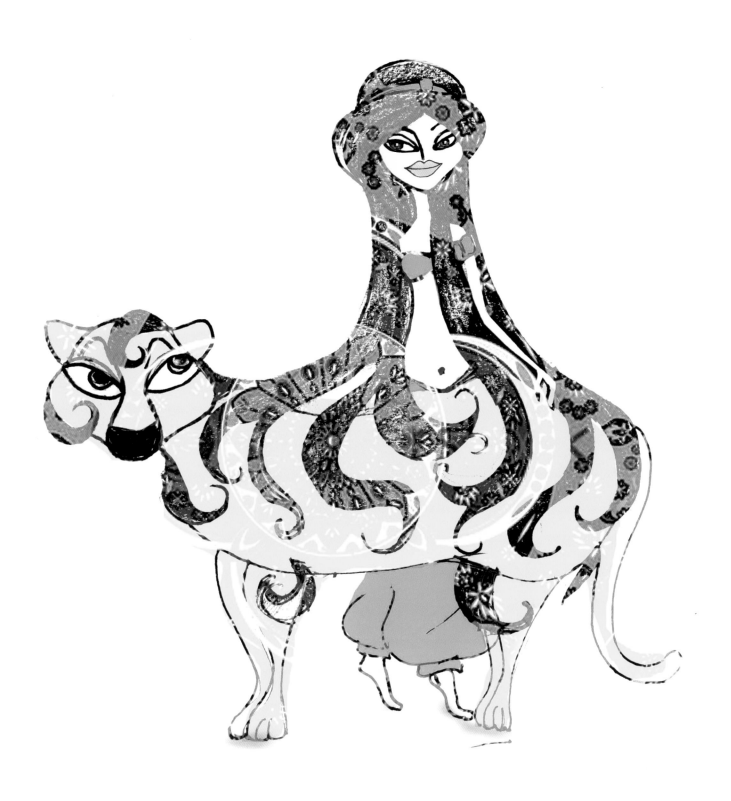

Jasmine
170 Maulshree Somani
Pencil and pen on paper and digital media

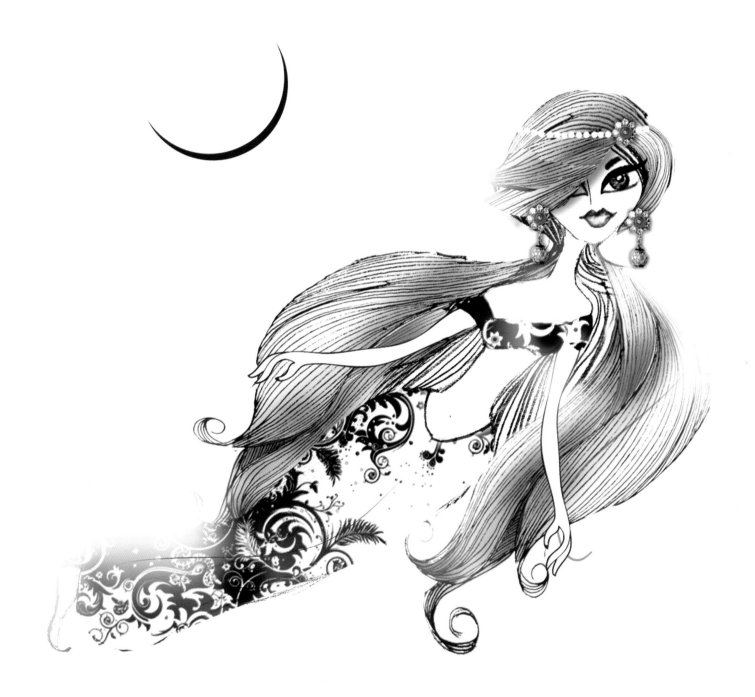

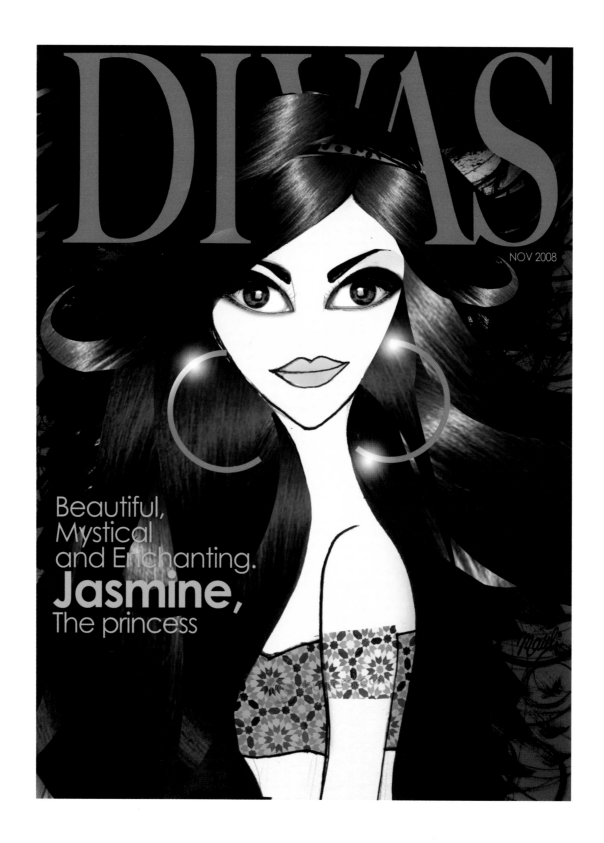

Jasmine

172 Maulshree Somani

Pencil and pen on paper and digital media

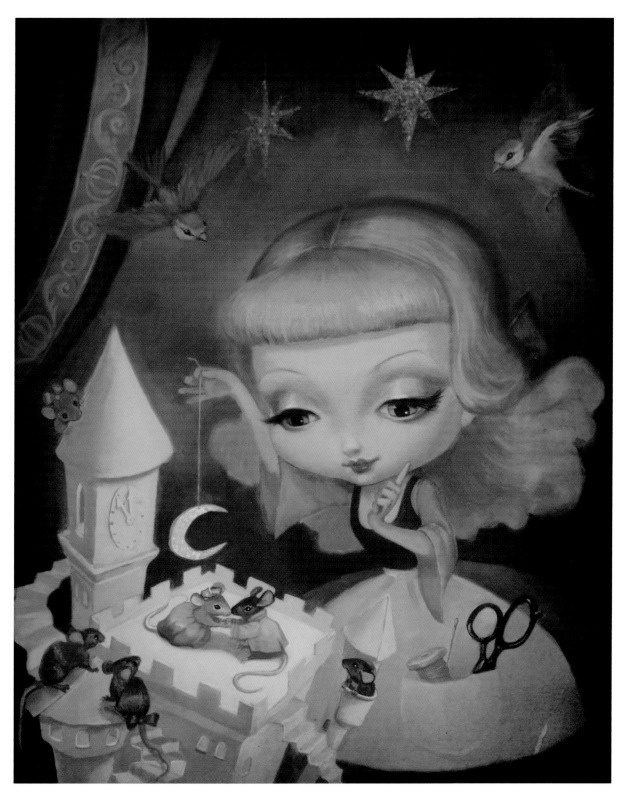

Cinderella
Olga Mosqueda
Canvas, acrylic, oil, and digital media

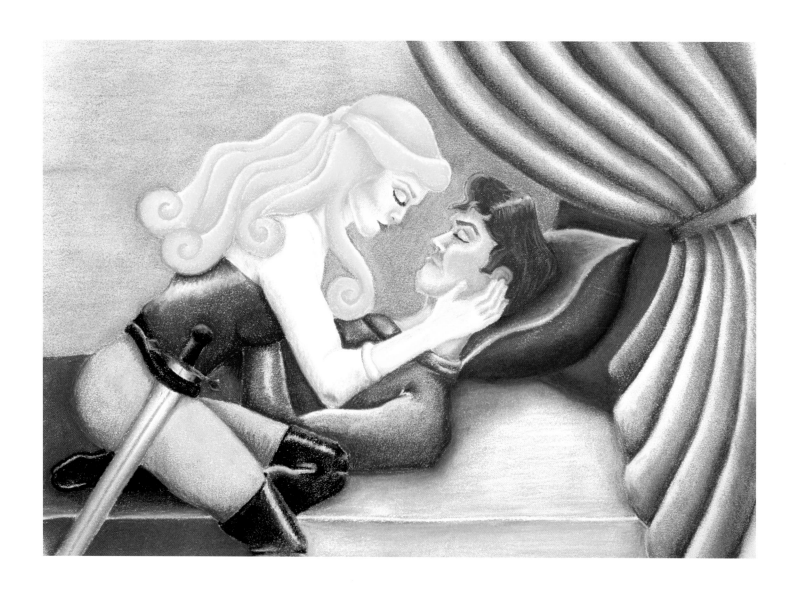

Aurora
174 Jessica Ward
Pastel pencil on paper

When I was little, I wanted to be Princess Aurora. I had long blond hair, I loved to sing, and I thought it would be just lovely to take a long nap and be awakened by the kiss of a handsome prince. Now that I'm grown up, I still have long blond hair, and I still love to sing, but I've become a bit more of a feminist. Don't get me wrong—part of me will always be that hopeless romantic who gushes over happy endings and rugged Romeos—I'm just not going to lie around waiting for said Romeo to appear. So when I started brainstorming ideas for this project, a thought immediately sprang to mind: what if I re-imagined an iconic moment from *Sleeping Beauty* in which Aurora's and Phillip's roles were reversed? It felt a little strange at first, altering such a classic image, but the more I thought about Aurora riding up on a powerful steed and slaying Maleficent, the more I liked the idea of a Princess taking her fate into her own hands. Because who said that a girl can't bring about her own happily ever after?

Jessica Ward

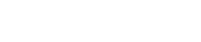

——— ⚜ ———

This book's producers would like to thank all of the artists who contributed to this book, Jennifer Eastwood, Soo Koo, John T. Quinn, Ken Shue, and Brent Ford.

For information address Disney Editions, 114 Fifth Avenue, New York, New York 10011-5690.
Editorial Director: Wendy Lefkon
Senior Editor: Jody Revenson
Assistant Editor: Jessica Ward

Designed by: Winnie Ho

Library of Congress Cataloging-in-Publication Data on file

ISBN 978-1-4231-2371-2

First Edition
10 9 8 7 6 5 4 3
F850-6835-5-12093
Printed in Singapore

D23

The Official Disney Fan Club

Disney.com/D23

——— ⚜ ———

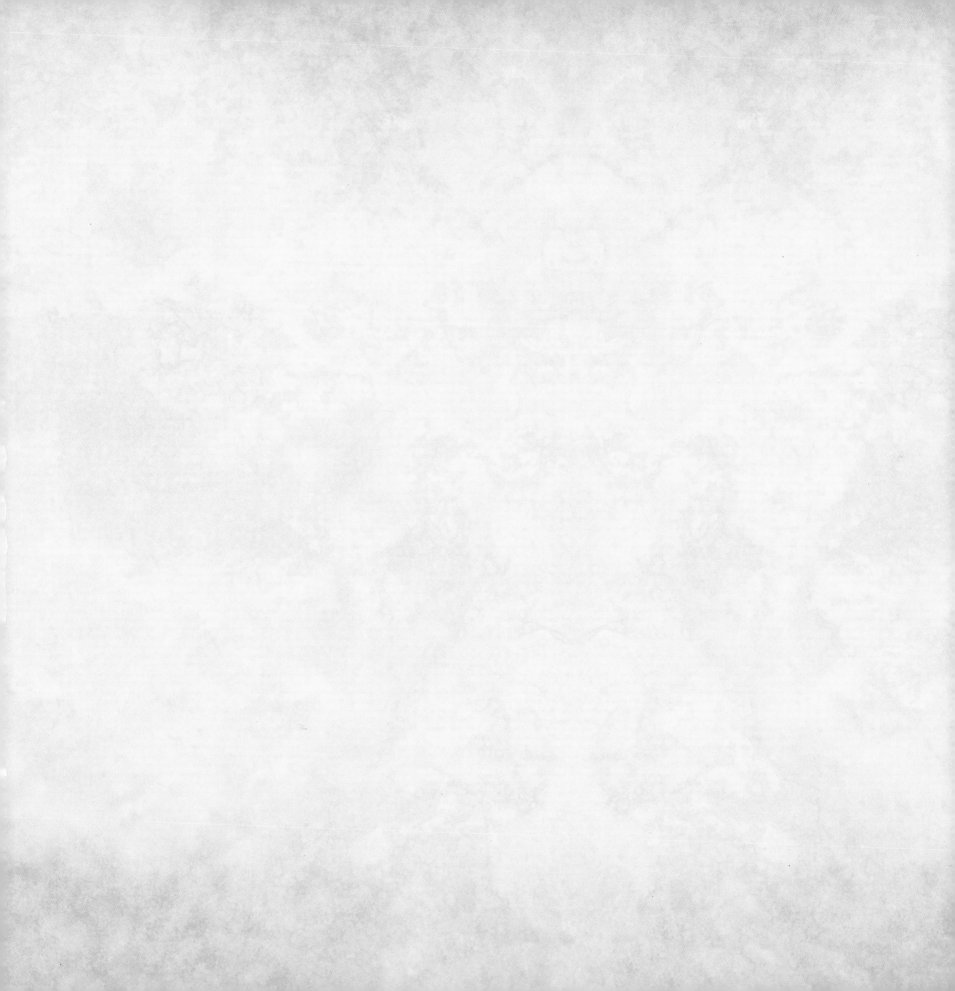